The Campus History Series

VIRGINIA UNION UNIVERSITY

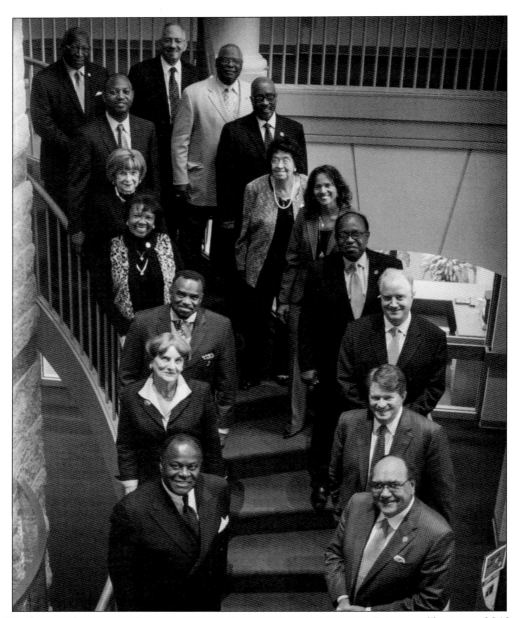

Dr. Claude Grandford Perkins and the Virginia Union University Board of Trustees, 2012. Virginia Union University's 12th president, Dr. Claude Grandford Perkins (lower right), is flanked by trustee board chair Dr. W. Franklyn Richardson (lower left), as the entire board of trustees stands on the spiral staircase in the main lobby of the L. Douglas Wilder Library and Learning Resource Center. (Courtesy of Ayasha Sledge.)

On the Cover: Members of the VUU 1940–1941 Varsity Club. This group of student athletes posing in front of Pickford Hall on the VUU campus includes players from the celebrated men's basketball "Dream Team" that won a CIAA conference title in 1939. Roland McDaniel (first row, second from left) was also a CIAA tennis champion. (Courtesy of the Archives and Special Collections of the L. Douglas Wilder Library and Learning Resource Center.)

The Campus History Series

VIRGINIA UNION UNIVERSITY

Dr. Raymond Pierre Hylton

ARCADIA
PUBLISHING

Copyright © 2014 by Dr. Raymond Pierre Hylton
ISBN 978-1-4671-2248-1

Published by Arcadia Publishing
Charleston, South Carolina

Printed in the United States of America

Library of Congress Control Number: 2014935841

For all general information, please contact Arcadia Publishing:
Telephone 843-853-2070
Fax 843-853-0044
E-mail sales@arcadiapublishing.com
For customer service and orders:
Toll-Free 1-888-313-2665

Visit us on the Internet at www.arcadiapublishing.com

To all those who helped in any way to make this book and the university it depicts possible; to family and friends; and, especially, to our friend Ronald Shelton—librarian, mentor, and role model—who is sorely missed and would have rejoiced in this publication.

Contents

Acknowledgments		6
Introduction		7
1.	Two Cities and One Mission: 1865–1899	9
2.	The Quiet Formation: 1899–1941	17
3.	Hartshorn Memorial College: 1883–1932	33
4.	In the Vanguard of Freedom: 1941–1970	51
5.	Storer College: 1865–1955	79
6.	An Enduring Mission: 1970–2015	85
7.	University Life: Throughout the Years	107

ACKNOWLEDGMENTS

First of all, I wish to acknowledge my team, without which this project could not have moved in the timely manner that it has: Selicia Gregory Allen, archivist at the Wilder Library; Dr. Luminita Dragulescu, assistant professor of languages and literature; Dr. Thomas Fensch, chair of the Department of Mass Communications; Dr. Adam Bond, assistant professor for church history; and Adam Zimmerli, librarian and adjunct history instructor. Further thanks go to Dr. Claude G. Perkins, president and CEO of Virginia Union University; Vanessa Coombs, Ayasha Sledge, and Gregory Lewis. The images in this book are from the archives and special collections of the L. Douglas Wilder Library and Learning Resource Center unless otherwise indicated. Deep thanks also go to acquisitions editors Julia Simpson and Gillian Nicol and the team at Arcadia Publishing.

INTRODUCTION

It had been a terrible four years.

From 1861 to 1865, a momentous turn of events occurred in the United States: the breaking of the shackles of bondage from some four million human beings at the cost of over 600,000 lives in a war that had nearly torn the nation apart. Slavery was gone, but how to ensure that those millions of former slaves could benefit from their new freedom by acquiring the skills, education, and economic viability so necessary for making that freedom endure? One group of dedicated individuals seeking answers was the American Baptist Home Mission Society (ABHMS).

Shortly after the liberation of Richmond, Virginia, on April 3, 1865, the ABHMS dispatched teachers and missionaries. Although the group was somewhat loosely organized at first, the schools and missions soon coalesced into Wayland Seminary in Washington, DC, and Richmond Theological School for Freedmen in the former Confederate capital. In 1867, the Richmond Theological School for Freedmen, after two years without a campus, succeeded, under the direction of Dr. Nathaniel Colver, in renting the former slave jail/auction house complex owned by notorious slave-trafficker Robert Lumpkin from Lumpkin's widow. Then, under Dr. Charles Henry Corey, the school acquired the former United States Hotel building at Nineteenth and Main Streets, and it became Richmond Theological Seminary.

On February 11, 1899, Wayland Seminary and Richmond Theological Seminary formally merged to establish Virginia Union University on pastureland along North Lombardy Street. The university's first president, Dr. Malcolm McVicar, planned and executed the construction of the original "Nine Noble Buildings," designed by the renowned architect John Hopper Coxhead in the late Victorian Romanesque style. Most were built of Virginia granite inlaid with Georgia pine and constructed in part by the students themselves. Classes began promptly at 8:45 a.m. on October 4, 1899.

Administrators Dr. George Rice Hovey and William John Clark established the institution on firm ground. Dr. John Malcus Ellison, the first African American president of VUU, shepherded the school through the unsettling experiences of World War II. Under Dr. Samuel Dewitt Proctor and Dr. Thomas Howard Henderson, VUU weathered the turbulent civil rights era, and Virginia Union and its students played a significant role.

The administrations of Dr. Allix B. James, Dr. David Thomas Shannon, Dr. S. Dallas Simmons, Dr. Bernard Wayne Franklin, Dr. Belinda C. Anderson, and Dr. Claude Grandford Perkins have had to wrestle with the dilemmas facing historically black colleges and universities

in the post-segregation age. As Virginia Union University approaches the 150th year of its existence, it remains true to its mission to its students, to the greater community, and to all members of its close-knit "VUU Family." The university resolves to continue to assure the promise of an unlimited future for all who study within its walls.

One

Two Cities and One Mission

1865–1899

In July 1867, on a humid, sweltering day on Broad Street in Richmond, Virginia, a chance meeting between a frail New England pastor and a widowed former slave triggered the making of a great Southern university. The pastor was Dr. Nathaniel Colver, a 73-year-old veteran of the abolitionist movement whose avowed purpose was to locate a campus site for the Richmond Theological School for Freedmen, which had never been properly organized and established in a set location. The widow was Mary Lumpkin, who had married Robert Lumpkin, the proprietor of the dreaded "Devil's Half Acre" (located at Shockoe Bottom), a slave-dealing complex that included a large jail building. In one of history's supreme ironies, Mrs. Lumpkin agreed to rent the complex to Dr. Colver to further his work in educating the newly freed slave population. In 1868, Dr. Colver's health deteriorated, and he retired, passing his mission to Dr. Charles Henry Corey. In Washington, two schools operated in separate locations but shared the same mission as Richmond Theological School for Freedmen. In 1867, Wayland Seminary and the National Theological Institute had merged into Wayland College & Seminary. In 1899, the Washington and Richmond seminaries were united, and Virginia Union University was launched.

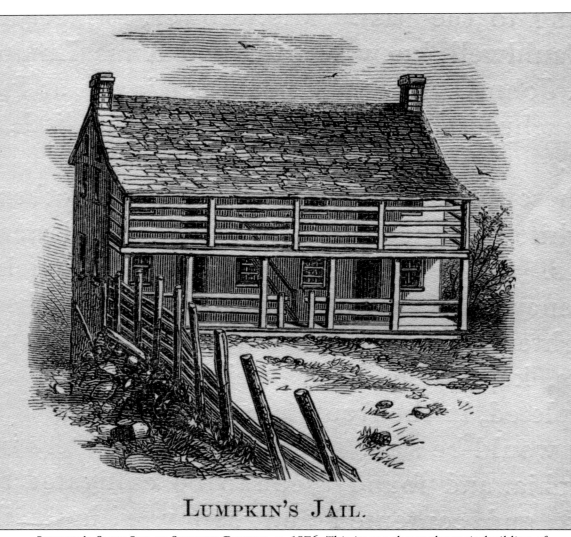

LUMPKIN'S SLAVE JAIL AT SHOCKOE BOTTOM, C. 1876. This image shows the main building of Robert Lumpkin's "Devil's Half Acre" (rechristened as "God's Half Acre" by Dr. Nathaniel Colver in 1867). Lumpkin's complex included four structures: a two-story brick prison, a hotel/auction building, a tavern/restaurant, and the Lumpkin family residence. When Lumpkin died in 1866, he bequeathed it all to his ex-slave wife, Mary. This image depicts the actual prison building, which was used by Dr. Colver (in 1867 and 1868) and Dr. Charles Corey (from 1868 through 1870) as the classroom/main dormitory. The iron bars were removed from its windows, the whipping ring was reputedly plainly visible, and the professors may have employed the whipping posts as lecterns. During the first year, Dr. Robert Ryland taught the nonreligious subjects, and Dr. Colver taught biblical studies.

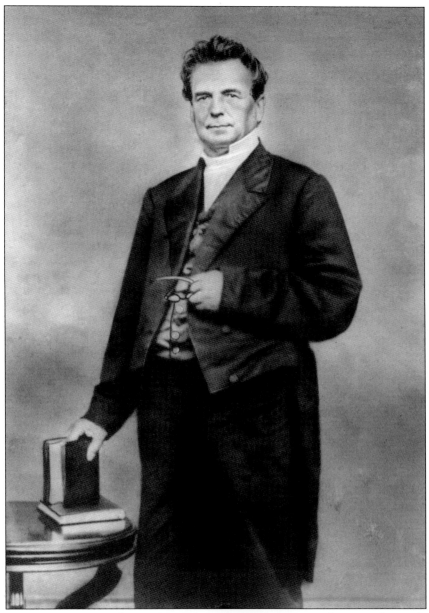

Dr. Nathaniel Colver, c. 1867. Aged and chronically ill by the time he arrived in Richmond in 1867, Colver (1794–1870) was born in Vermont and raised in Massachusetts. A pastor, scholar, administrator, and social activist who championed the abolition and temperance movements, Colver earned his doctorate in divinity at Denison University. After moving to Chicago, Illinois, he served as professor of biblical theology at the University of Chicago, joined the American Baptist Home Mission Society, and was among the first to propose that teachers and facilities be provided for the freed slave population of the South and that institutions be founded for the purpose of educating that population so that they could better enjoy the fruits of their freedom. Colver established the Richmond Theological School for Freedmen campus at the Lumpkin's Jail site and resided and taught there for a year before he retired.

FIRST AFRICAN BAPTIST CHURCH. This church, founded in 1841, is the oldest African American church in Richmond, Virginia. It was just outside of this building—on the corner of College and Broad Streets—that Dr. Nathaniel Colver met Mary Lumpkin and arranged to rent her premises as a campus for Richmond Theological School for Freedmen. (Courtesy of Library of Congress.)

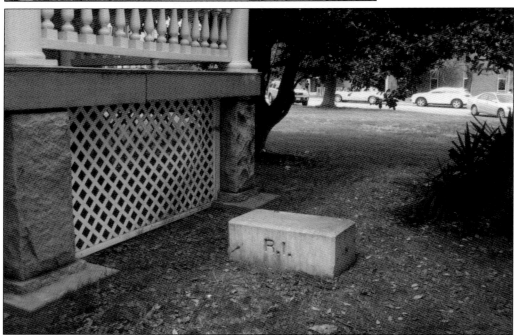

CARRIAGE STOOP AT VUU NINETEENTH AND MAIN STREET CAMPUS. This carriage stoop was especially useful for ladies descending from horse-drawn vehicles (as a deterrent against soiling their laced boots or the hems of their dresses). "R.I." denotes Richmond Institute—the school's name from 1876 to 1886. The stoop was ultimately moved from its original site to the front of the Baptist Memorial Hall facing Lombardy Street.

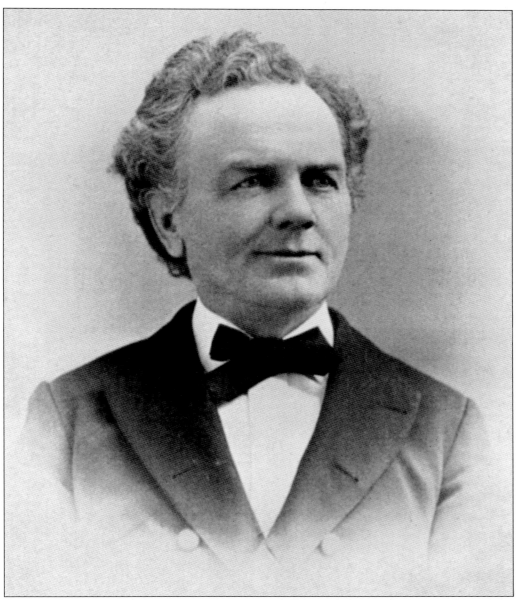

DR. CHARLES HENRY COREY (1834–1899). Dr. Corey was born in the town of New Canaan in New Brunswick, Canada, and was ordained to the Baptist ministry in 1861. During the Civil War, he served as a pastor to the US armed forces as a member of the Christian commission; afterward, he helped to found and direct the future Morehouse College (then known as Augusta Theological Institute). After taking over for Dr. Nathaniel Colver at the Lumpkin's Jail site, Corey headed the Richmond Theological School for Freedmen for 30 years, writing the first historical accounts of the school. In 1875, the first African Americans were named to the board of trustees (pastors James H. Holmes and Richard Wells), and an alumni association was formed in 1879. During the course of the 1890s, Corey helped forge the merger of the Richmond Theological School for Freedmen with Wayland Seminary to form Virginia Union University; the onset of Bright's disease forced Corey's retirement in 1898.

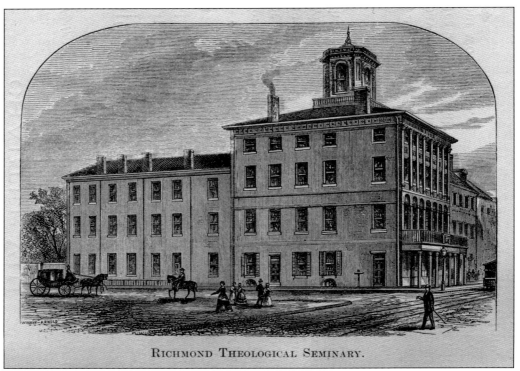

RICHMOND THEOLOGICAL SEMINARY.

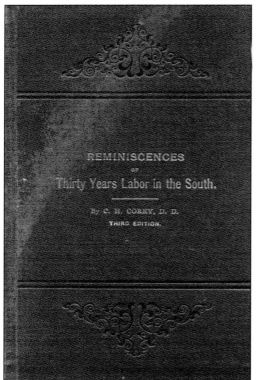

THE UNITED STATES (OLD UNION) HOTEL. The former hotel stood at Nineteenth and Main Streets and became the site of the second campus for the Richmond Theological School for Freedmen. A $10,000 subsidy from the Freedman's Bureau enabled Dr. Charles Henry Corey to purchase the building and move the school from Lumpkin's Jail in 1870.

DR. CHARLES HENRY COREY'S BOOK. In 1895, while entering the final years of a long career in teaching and in the ministry, Dr. Corey published the first definitive account of the Richmond school's establishment under the title *A History of the Richmond Theological Seminary With Reminiscences of Thirty Years' Work Among the Colored People of the South*.

Dr. Joseph Endom Jones (1852–1922). Born into slavery in Lynchburg, Virginia, Jones was forced by his master to labor in a tobacco factory at the age of six. His mother secretly arranged for him to be taught to read and write, and after the Civil War, he attended a private school in Washington and then attended Colver Institute from 1868 to 1871, receiving the equivalent certification for a bachelor of arts degree. He pursued his studies at Colgate University, where he received his master of arts degree, and Selma University, where he earned a doctorate in divinity. In 1876, he was appointed professor of homiletics and philosophy at Colver Institute and embarked on a 46-year college teaching career, eventually transitioning from Colver/Richmond Institute to Virginia Union University. At the time of his death, he was the senior professor at VUU and the last living link to the Lumpkin's Jail campus.

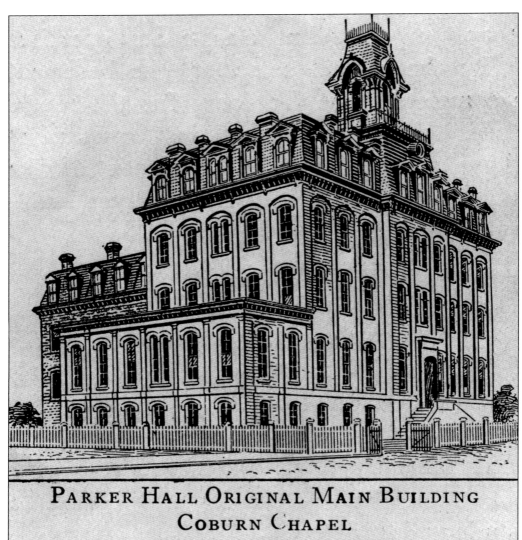

PARKER HALL ORIGINAL MAIN BUILDING
COBURN CHAPEL
WAYLAND SEMINARY

PARKER HALL AT MERIDIAN HILL, WAYLAND SEMINARY. This building served as the main campus structure for Wayland Seminary in Washington, DC, from 1876 to 1899. Founded in 1865, Wayland Seminary occupied several locations before settling at Meridian Hill. Under the leadership of Dr. George Mellen Prentiss King, who headed the school from 1867 to 1897, Wayland Seminary gained a reputation for its rigorous academic curriculum and its singing quartet. Notable students and graduates include Dr. Adam Clayton Powell Sr., founder-pastor of Harlem's Abyssinian Baptist Church; Dr. Booker T. Washington, Tuskegee Institute president and author of *Up From Slavery*; Henry Vinton Plummer, first African American chaplain in the US Army; Alfred L. Cralle, inventor of the ice cream scoop; and Kate Drumgoold, author of *A Slave Girl's Story: Being an Autobiography of Kate Drumgoold*, published in Brooklyn, New York, in 1898.

Two

THE QUIET FORMATION
1899–1941

After Virginia Union University's first Founders' Day ceremony on February 11, 1899, the genius and determination of its first president, Dr. Malcolm MacVicar, and master architect John Hopper Coxhead had solidified the fledgling institution so effectively that by October of that same year, academic life was in place. VUU operated a remedial program and a high school division, preparing its students for bachelor's degree programs in arts, science, and divinity. By 1918, the university had expanded through the acquisition of land for an athletics field; the construction of a second dormitory; the establishment of a teacher education program, a law school; the ROTC program; and a curriculum based on the W.E.B. Du Bois model. In the 1920s and 1930s, VUU transformed from an all-male to a coeducational institution.

Dr. Malcolm MacVicar (1829–1904). Dr. MacVicar was the first president of Virginia Union University, serving from 1899 until the day of his death on May 18, 1904. He was a native of Scotland, born in Argyleshire, and was taken by his parents to Canada. He graduated from the University of Rochester and embarked on a career in the ministry and education, teaching and administering at places as diverse as Brockport and Potsdam, New York; Leavenworth, Kansas; Ypsilanti, Michigan; and Hamilton, Ontario, before becoming secretary of the American Baptist Home Mission Society. Known as "that man of iron and steel" for his indomitable will and strength of character, MacVicar organized the establishment of Virginia Union University at its Lombardy Street campus and the construction of the "Nine Noble Buildings" using Virginia granite and Georgia pine and set the school's academic program and curricula in motion.

"First Founders' Day" Article. In 1949, Dr. Joseph T. Hill wrote the only known eyewitness account of the ground-breaking ceremony at Lombardy Street that launched Virginia Union University on February 11, 1899. The ceremony nearly ended in disaster when the elderly Dr. Lyman Beecher Tefft, president of Hartshorn Memorial College, almost fell off the speaker's platform but was rescued by VUU professor Dr. David Nathaniel Vassar.

Virginia Union Bulletin 23

The First Founders' Day

Related by Dr. Joseph T. Hill

On February 11, 1899 as students of Richmond Theological Seminary, we were told to assemble on the grounds known commonly then as "Sheep Hill", now Virginia Union University, to witness the ground breaking exercises.

It was a beautiful day, and there were approximately one hunderd persons present, the faculty and students of Hartshorn College were invited: Dr. Corey and staff, Dr. Jones, Dr. Vassar and Dr. Genung.

The exercise itself was very simple. Two hymns were sung. Dr. Genung led "A Mighty Fortress Is Our God," Prayer was by Dr. Jones. Dr. Corey provided the second hymn led by Joseph T. Hill, "God Moves in Mysterious Ways." General Morgan spoke first. He was a member of the American Baptist Home Mission Society. He was followed by Dr. Morehouse, who was also a member of the American Baptist Home Mission Society, and in whose honor Morehouse College is named.

An incident with human interest meaning occurred during the ground-breaking exercise. As Dr. Tefft was mounting the crudely built platform, his foot slipped and he was prevented from falling by Dr. Vassar. At this time, Dr. Tefft made the significant statement, "This is not the first time a Negro has helped a white man to position."

The grounds were at that time outside of the city limits and Mr. Carter was then superintendent of the grounds. The exercises were held on the site now the location of Kingsley Hall, and are known to us today as the first Founders' Day.

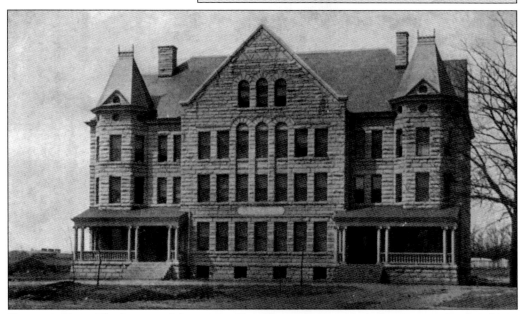

Kingsley Hall. The largest of the original buildings designed by John Hopper Coxhead was named for Chester Kingsley, who contributed $25,000 toward the dormitory's construction. Kingsley was the president of the American Baptist Home Mission Society. The four floors of dormitory quarters were completed even before the staircases were built, so at first, students had to climb ladders from one floor to the next in order to reach their rooms.

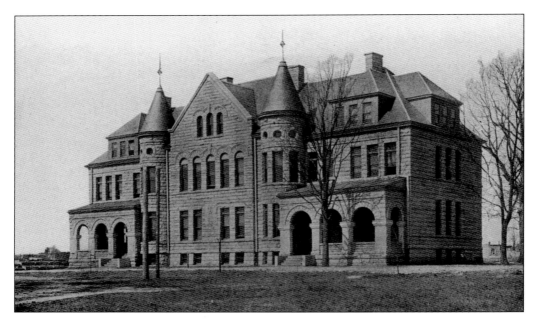

PICKFORD HALL AND CHEMICAL LABORATORY. Pickford Hall, the main administrative building throughout the university's history, was named for the late C.J. Pickford, a Richmond Theological Seminary Board of Trustees member from 1886 to 1899. The building was to house the offices of the university president and the dean and to serve as the main classroom building. Pickford Hall still functions as the administrative hub, with the offices of the president and the provost/vice president for academic affairs on the first floor. Though it was supplanted by Ellison Hall as the largest classroom building, Pickford Hall contains the offices and classrooms for the Sydney Lewis School of Business. In the early days, the Pickford Hall basement held the chemistry, biology, and physics laboratories.

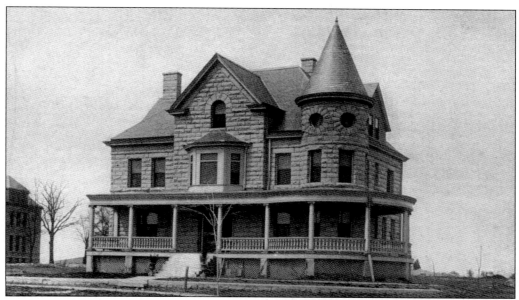

PORTER COTTAGE (ABOVE) AND BAPTIST MEMORIAL HALL (BELOW). These two buildings fronting Lombardy Street were inverted "twins" of each other. Porter Cottage, named for the parents of Henry Kirke Porter (1840–1921), a congressman from Pennsylvania and a wealthy locomotive manufacturer, was the residence of VUU president Malcolm MacVicar. In 1904, it became known as Teacher Cottage because it was used as an on-campus residence for distinguished professors. In 1965, the cottage was demolished to make way for the Ellison Hall building. Baptist Memorial Hall was originally dean George Rice Hovey's residence, and he remained there after assuming the presidency. It was used as the residence of the three succeeding presidents until 1950 and now provides office space.

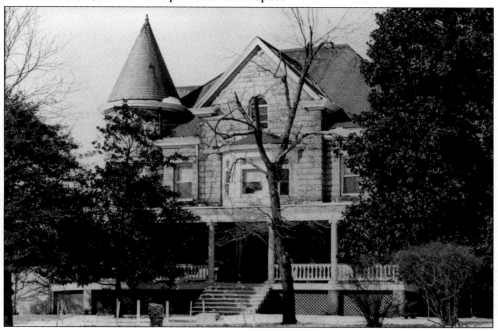

MARTIN E. GRAY HALL. The original cafeteria, Martin E. Gray Hall was dedicated to deacon Martin E. Gray from Willoughby, Ohio, who had risen from poverty and, through a strong work ethic, had become a very wealthy farmer and landowner. Gray heard about the project for building Virginia Union University and donated $20,000. Students met at Martin E. Gray Hall in February 1960 to launch the Richmond sit-ins.

COBURN HALL. Called the "vibrant heart" of VUU, Coburn Hall was named for Gov. Abner Coburn of Maine (1803–1885), an abolitionist who had supported and donated to Wayland Seminary. Coburn Hall originally functioned as the university chapel and university library. Its walls have resonated with the voices of many notable speakers, including Dr. Martin Luther King Jr., former president William Howard Taft, and Langston Hughes, who gave his first poetry recital in the South here on November 19, 1926.

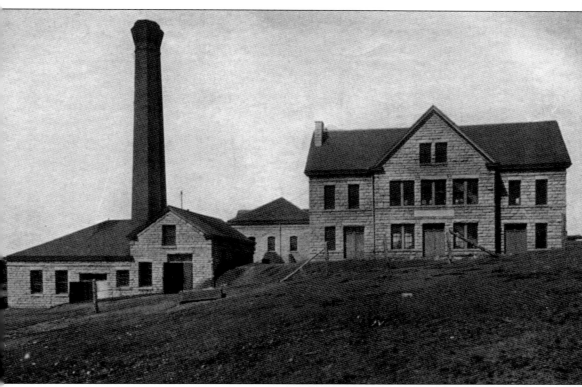

THE "FORGOTTEN THREE" BUILDINGS. Often overlooked because they were placed offtrack, so to speak, at the extreme southwestern edge of the campus and fell into disuse, these "forgotten three" of the nine original buildings performed nonacademic functions. The power plant (at left), with its conspicuous red smokestack, was designed to make the university self-sufficient in generating its electrical power. The barn at the center of the picture (the least photographed of the three structures) was demolished in the 1920s. It housed cows, horses, pigs, and chickens that provided milk, eggs, meat, and transportation for faculty, staff, and students. In those days, a student's "work-study" assignment often entailed taking care of the animals and maintaining the barn. The Industrial Hall building at right provided a venue for the manual/technical training that was a common feature of educational institutions of the era.

STUDENTS AT WORK IN INDUSTRIAL HALL. The Industrial Hall contained two stories and an attic. The ground floor contained an iron/metal fabrication shop, a blacksmith forge, and a molding room. On the second floor, a carpenter's shop was set up with workbenches, two complete sets of carpenters' tools, and turning lathes—a smaller room was set aside to provide instruction in mechanical drawing. The attic was designed to store both working material and finished work produced by students, who were assigned into class groups that numbered no more than 24. An elevator was installed in the building to transport students and instructors between floors.

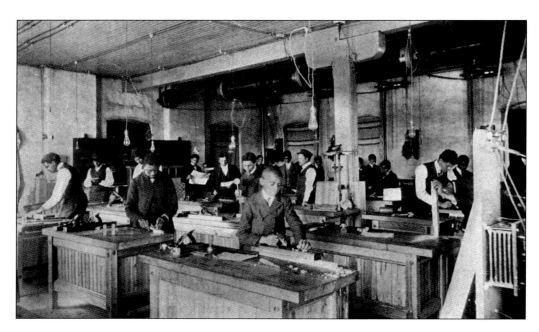

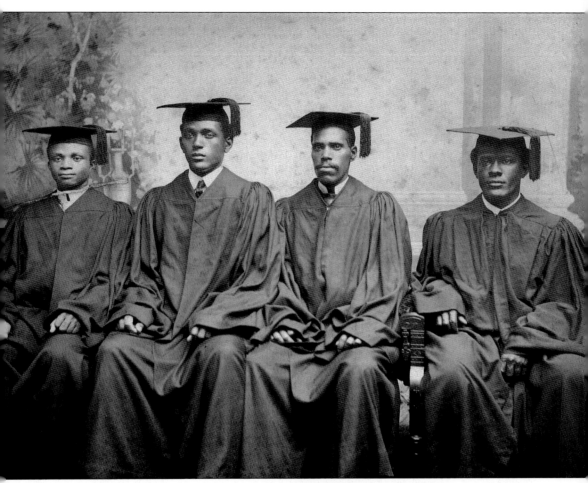

First Virginia Union University Graduating Class, 1902. The first bachelor of arts degrees given under the auspices of the new university were presented at the 1902 commencement. The recipients were, from left to right, John William Barco, George Leander Bayton, Napoleon Bonaparte Curtis, and Samuel Leonidas Wade. Barco was born in Shiloh, North Carolina, and entered Wayland Seminary in 1898 before transferring into VUU. He pursued postgraduate studies at the University of Chicago and Newton Theological Seminary. He secured employment at his alma mater as a teacher in 1903. From 1928 until his retirement in 1953, Barco was the vice president of VUU, then served as vice president emeritus until he died in 1964. He became legendary as a particularly conscientious administrator and rigid disciplinarian. Because of his ardent support for the VUU athletics program, Barco-Stevens Hall, which contains the gymnasium, was named for him (and for mathematics professor Wesley Stevens).

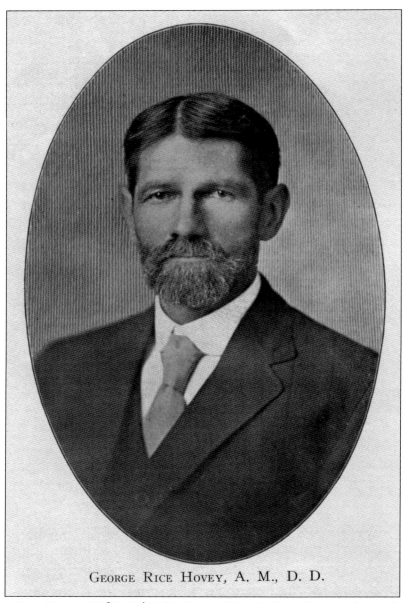

GEORGE RICE HOVEY, A. M., D. D.

DR. GEORGE RICE HOVEY (1860–1943). Dr. Hovey, Virginia Union's second president, served from 1904 to 1918 and had a strong athletic background as a star player on the Brown University baseball team. Unsurprisingly, he established the VUU sports program by buying the lot across from the campus on Lombardy Street for use as a playing field—which is still known as Hovey Field—and entering Virginia Union into the CIAA (then Colored Intercollegiate Athletic Association but now Central Intercollegiate Athletic Association) in 1912 as a charter member to compete with Howard, Hampton, Shaw, and Lincoln. The Hovey administration was similarly notable for nearly doubling the library's collection, constructing the Huntley Hall dormitory and the King Gate columns at the campus entrance, and starting the first ROTC program in 1917. In 1919, Dr. Hovey assumed the post of superintendent of education for the American Baptist Home Mission Society.

KING GATE. Dr. George Mellen Prentiss King (1833–1917), from Portland, Maine, was an intensely committed abolitionist. King matriculated at Colby University in 1857 and was fired from his position as president of Maryland Agricultural College in 1859 because of his outspoken support for John Brown's raid on Harpers Ferry. King served as president of Wayland Seminary from 1867 to 1897. At age 66, Dr. King took up a position on the Virginia Union faculty. One of VUU's most striking landmarks, the King Gate, was dedicated to him in May 1914. An entrance into the campus once ran between its two granite columns, which were installed facing Lombardy Street between the future site of Ellison Hall and the driveway leading to Pickford Hall.

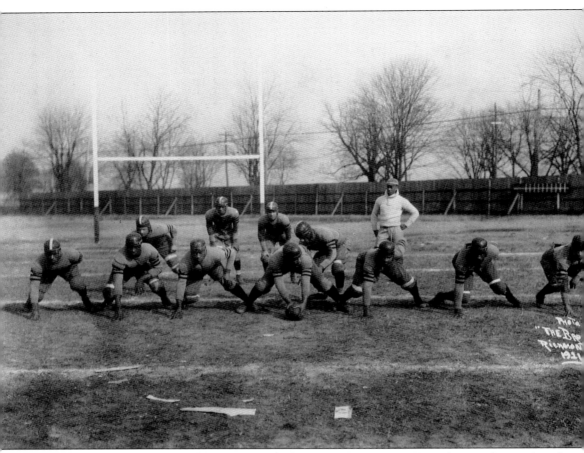

HOVEY FIELD WITH FOOTBALL SQUAD, 1921. When Pres. George Rice Hovey's name is mentioned on the Virginia Union campus, it is most often in connection with the athletic program that he fostered. The tract of land across Lombardy Street was not originally part of the property acquired by the American Baptist Home Mission Society; in 1907, Dr. Hovey authorized the purchase of 11 acres of the block between Lombardy, Brook Road, and Admiral Street for $8,483.55. The field was set aside for athletic events and known as Hovey Park or Hovey Field. The school eventually built a full-size stadium, and the field is still home to the VUU Panthers teams and is also, weather permitting, used for commencement ceremonies. The stadium holds the distinction of being the nation's second-oldest university stadium (after Harvard University's) and the oldest that still uses natural field vegetation.

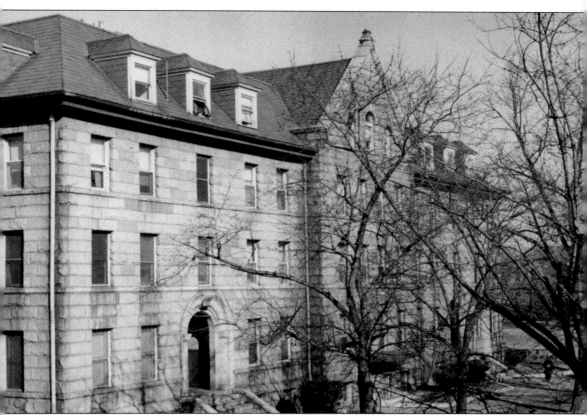

HUNTLEY HALL. VUU's second dormitory building was named for Byron E. Huntley, who was from Batavia, New York. Huntley served as president of the Richmond Theological Seminary Board of Trustees from 1895 to 1899 and was a VUU trustee board member from 1899 to 1906. Within five years of the university's establishment, enrollment had burgeoned, and Kingsley Hall no longer provided adequate housing; overcrowding became an urgent issue. In 1906, Huntley bequeathed $10,000 to the university, and his sister, Frances Huntley, donated an additional $15,000. Built in a style similar to the Victorian Romanesque of the "Nine Noble Buildings," Huntley Hall, designed by famous African American architect Charles Thaddeus Russell, was built in stages during 1911 and 1912 and dedicated in 1913. Russell later designed the King Gate, and Huntley Hall itself eventually became a coeducational dormitory with separate floors to house men and women.

DR. WILLIAM JOHN CLARK (1877–1956). Dr. Clark, third VUU president, achieved the lengthiest tenure of any chief executive officer by serving for 22 years (from 1919 to 1941). A native of Albion, Nebraska, he was a veteran Baptist minister by the time he came to VUU in 1913 as an instructor in history, English, and religious studies. Under the Clark administration, VUU became coeducational, and Hartshorn Memorial College merged into the university (in 1932); Hartshorn Memorial Hall dormitory was built for women students (in 1934); the teacher education program began (in 1922); the Norfolk Division (later Norfolk State University) was set up (in 1935); industrial education was abandoned as the university wholly adopted the W.E.B. Du Bois educational model; and a law school operated from 1922 to 1931. Clark retired in 1941 and continued to serve VUU as professor of religion and president emeritus until he passed away at age 79.

MARY S. BOOKER AND THE *PANTHER*. The academic year 1927–1928 saw the advent of the *Panther*, the VUU yearbook. It was a transitional time; Virginia Union was being transformed from an all-male to a coeducational institution as Hartshorn Memorial College for African American women was merging into the university. This was not without some opposition from those who saw more advantage in single-sex education and/or who feared that coeducation might open the door to lust and promiscuity. As a sign of the changing times, the first Miss VUU—a freshman named Mary S. Booker, from Richmond—was crowned during halftime of the football game held on Thanksgiving Day in 1927.

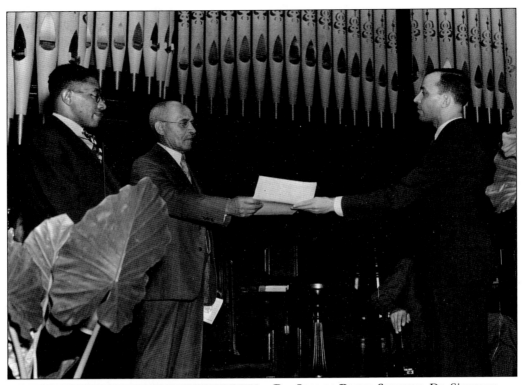

DR. JOSHUA BAKER SIMPSON. Dr. Simpson (center) taught at VUU for 52 years (from 1891 to 1943). He was a terror to his students if they strayed from his dress code or rules for classroom etiquette or were one second late for his lectures. True to his standards on decorum, he always wore a full dress suit with a tie, even in weather with temperatures over 90 degrees and 100 percent humidity.

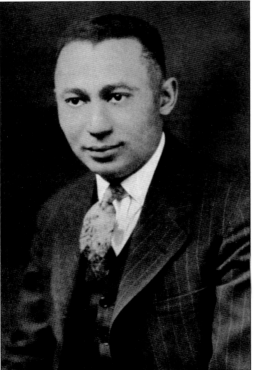

DR. RAYFORD WHITTINGHAM LOGAN (1897–1982). Dr. Logan earned worldwide renown for his pioneering work in African American history, particularly on the "'nadir' of race relations" (a phrase he coined) during the Gilded Age and Progressive Era. Logan taught at VUU from 1925 to 1930 and was chair of the history department. A candid and controversial man, he ruffled feathers within the administration.

Three

HARTSHORN MEMORIAL COLLEGE
1883–1932

Providing African American women with collegiate-level education posed a challenge after emancipation. Richmond Theological School for Freedmen was primarily designed to cater to the needs of young male students aspiring to the ministry and was ill-prepared to offer facilities for women who sought instruction. In 1883, Joseph C. Hartshorn and his friends Dr. Lyman B. Tefft and Carrie Dyer established Hartshorn Memorial College. The college was named after Hartshorn's late wife, Rachel, and, during its first year, met in the basement of Ebenezer Baptist Church. In 1884, the school moved to a permanent location at Leigh and Lombardy Streets, using former Bowe Plantation buildings as the classrooms, dormitory, and president's house. The college operated under strict rules: the girls were diligently chaperoned, sweets and pastries were totally banned, and chapel attendance was mandatory. Tefft was wary of coeducation, though Hartshorn acted as a sister institution to neighboring Virginia Union University. After Tefft's retirement in 1912, Hartshorn entered a closer partnership with Virginia Union under the more flexible presidency of George W. Rigler. In 1932, after VUU became coeducational, the two schools merged.

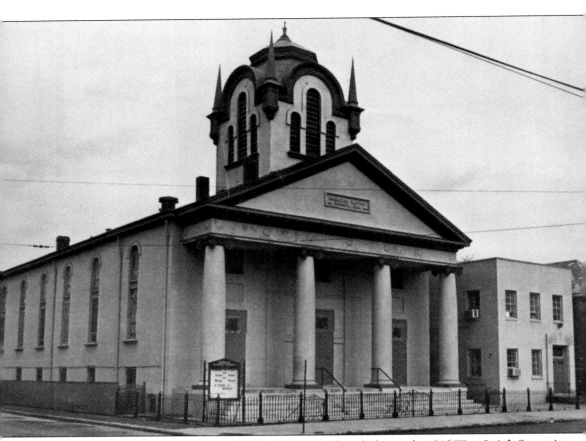

EBENEZER BAPTIST CHURCH. Founded in 1857, this church, located at 216 West Leigh Street in the Old Jackson Ward area of Richmond, sports a distinctive Neoclassical architectural style designed by Charles Thaddeus Russell and has long-standing connections with VUU. Richard Wells, who served on VUU's board of trustees from 1875 to 1901, was the pastor at Ebenezer from 1870 to 1901. Russell was a professor of industrial work and superintendent of buildings and grounds at VUU. In 1866, Ebenezer established Richmond's first free school for African Americans, which met in its basement. In 1883, Hartshorn Memorial College, an institution exclusively dedicated to furthering the education of African American women, assembled and held classes in the basement of the church. After the 1883–1884 academic year, Hartshorn administrators purchased land and buildings from the former Bowe Plantation, located at Leigh and Lombardy Streets, and moved the school into a more permanent home.

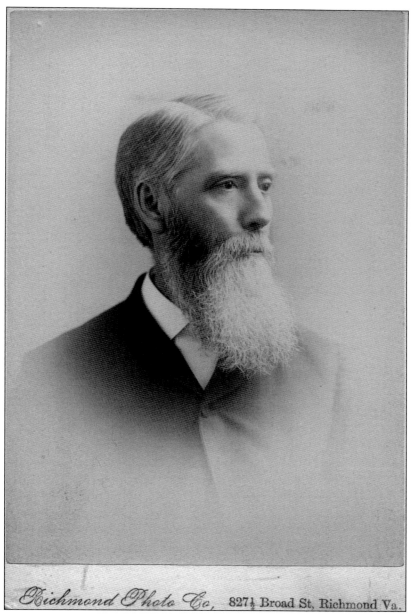

Dr. Lyman Beecher Tefft (1833–1926). Born in Exeter, Rhode Island, Tefft was first and foremost a minister, having earned a doctorate in divinity from Brown University; matriculated at Rochester Theological Seminary; and, during the 1860s and early 1870s, shepherded several churches. In 1873, however, he was called to the principal's position at Nashville Normal and Theological Institute, which focused on training African American ministers and teachers. Tefft had advanced views on women's equality, and in 1883, he was able to launch his idea of Christian education for young black women as crucial to advancing the cause of civil rights for all races. During his nearly 30 years as president of Hartshorn Memorial College and 93 years of living, he would see the widespread acceptance of most of his ideas on female equality and education.

CARRIE VICTORIA DYER (1839–1921). Born in Constantine, Michigan, Dyer received a strong Christian abolitionist upbringing and was trained as a teacher. She began her career in public schools and, in 1870, secured a position as an instructor at Nashville Normal and Theological Institute, where she met Dr. Lyman Beecher Tefft. When Dr. Tefft and Joseph Hartshorn established Hartshorn Memorial College in 1883, Dyer agreed to relocate to Richmond and serve as principal. By all indications, her collaboration with Tefft was a virtually equal partnership, with Dyer taking a proactive role in fundraising, representing the college, and day-to-day administration—where her practical and activist manner contrasted with the grandfatherly Tefft's more laid-back approach. Upon Tefft's retirement in December 1912, Dyer was named dean of Hartshorn and served in that capacity until 1914, then as an instructor until 1915, when she retired to Rhode Island.

HARTSHORN STUDENTS VICTORIA JOHNSON (RIGHT) AND HARRIET AMANDA MILLER (BELOW). The young women admitted to Hartshorn Memorial College were seen by president Lyman Beecher Tefft, dean Carrie Dyer, and Joseph Hartshorn as being the vanguard of a moral uplift within the African American community that in turn would advance the cause of equal justice for African Americans as a whole. As educated, refined, and Christian models for their husbands and children, and as teachers and missionaries, these Hartshorn alumnae could exercise influence in ways hitherto untapped. Miller, from Charlottesville, Virginia, was one of three Hartshorn graduates who, in 1892, received the first baccalaureate degrees ever conferred at an African American women's college—a bachelor of science.

DIXIE ERMA WILLIAMS (LEFT) AND THE POINDEXTER GIRLS: EARNESTINE, FRANNIE, AND MAUDE (BELOW). At Hartshorn, as at Virginia Union, college often became a "family affair," with sisters, brothers, parents, and children—even to three generations—attending a close-knit college where everyone knew most of the students and faculty on campus. This tradition is still very much in evidence at Virginia Union. Dixie Erma Williams, from Milan, Tennessee, was a classmate of Harriett Amanda Miller, who graduated in 1892, and also a recipient of the one of the first three bachelor of science degrees conferred at Hartshorn.

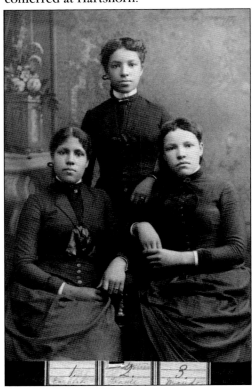

Clara Whitten (right), Industrial Teacher, and Cora Johnson (below), Hartshorn Student. While stressing a close, proactive approach to instruction, Hartshorn Memorial College president Lyman Beecher Tefft and dean Carrie Dyer remained adamant about two principles that tended to hamper the school financially. One was the emphasis on academics over domestic or manual education—while Hartshorn did provide homemaking and technical training, importance, as it was at Virginia Union, surrounded mastery of the liberal arts and sciences. The other was adherence to the belief that single-sex education was preferable over the coeducational model. As Tefft writes in the *First Annual Catalogue of Hartshorn Memorial College (1883–1884)*: "The Utopian notion that young people can be brought promiscuously together and counted as brothers and sisters, human nature laughs to scorn."

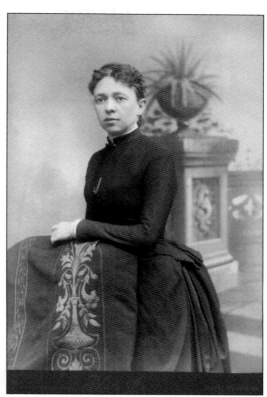

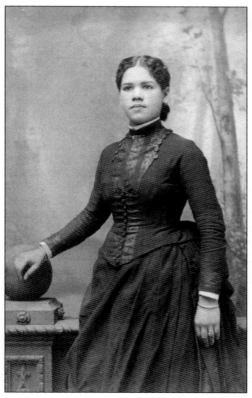

ROSA KINCKLE JONES (1858–1932) AND HER SONS. Hartshorn Memorial College was a family-oriented school. As the only African American teacher on the Hartshorn faculty and as the wife of respected VUU professor Joseph Endom Jones, Rosa Kinckle Jones was in a unique position to serve as a mentor and role model to the young ladies under her care. She graduated through the normal (teacher certification) program at Howard University in 1880, and secured a position at Hartshorn by 1888. She remained at Hartshorn as a music instructor for nearly 40 years, rising to the position of music director. Her elder son, Eugene Kinckle Jones (1885–1954), graduated from VUU in 1905 and became famous as one of the founding "jewels" of the Alpha Phi Alpha fraternity and for his work as executive secretary of the Urban League. Eugene (on the right) is pictured with his brother Joseph Jones Jr.

MAIN BUILDING OF HARTSHORN MEMORIAL COLLEGE. Hartshorn, located for 48 years at 1600 Leigh Street, acquired buildings from the antebellum Bowe family plantation. A few years after Hartshorn merged with Virginia Union in 1932, the Hartshorn buildings were razed, and Maggie Walker High School (now the Maggie L. Walker Governor's School) was built in its place.

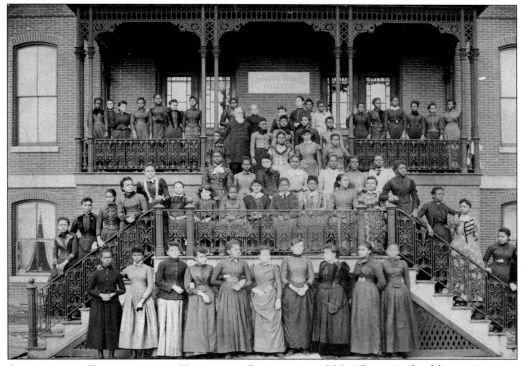

STUDENTS AND FACULTY ON THE HARTSHORN BALCONY, C. 1890. The main building's intricate balcony proved to be quite a popular venue for students and faculty to congregate for photographs. Despite the air of openness, the girls were very strictly chaperoned; faculty had the right to inspect rooms at any time, and sweets and pastries were totally forbidden.

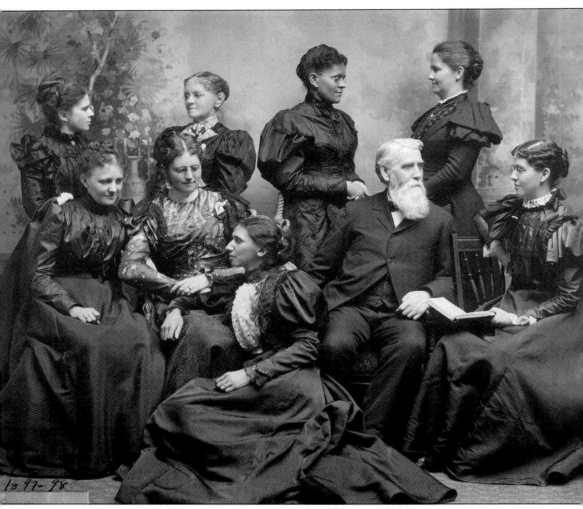

HARTSHORN MEMORIAL COLLEGE FACULTY, 1897–1898. The assembled Hartshorn faculty includes, from left to right, (first row) Miss Clark, Miss Moore, Rosa Kinckle Jones, Lyman Beecher Tefft, and Mary Tefft; (second row) Miss Jewett, Carrie Dyer, Mrs. Coleman, and Mrs. Gowan. Lyman Tefft was the only male faculty member. Mary Tefft was Lyman's daughter. The school budget was run on a shoestring, and Hartshorn had no endowment or dependable source of funding. Salaries were sometimes delayed or deferred, and Mary Tefft not only refused to accept a salary for her teaching but on occasion paid for student or university expenses out of her own savings. This proved a problem as time elapsed, because the American Baptist Home Mission Society favored Virginia Union and became determined to merge Hartshorn with VUU to insure financial viability.

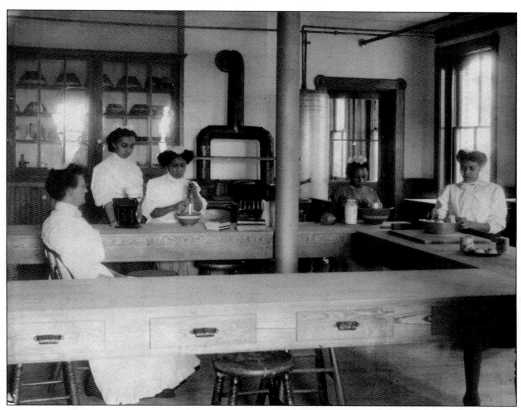

COOKING AND PEDAGOGIC CLASSES. Hartshorn had to tread an uneasy line between elements of its mission—on one hand, to prepare its students for their roles as wives and mothers, and on the other, to train and equip them for lives as professionals. Hartshorn pioneered and excelled in teacher education. Pedagogic classes were small, close-knit, and intense. In the 1910s, Hartshorn added a trailblazing "model classroom" that incorporated essential elements of present-day student teaching. The advent of a teacher education program at Virginia Union was heavily inspired and influenced by the Hartshorn example.

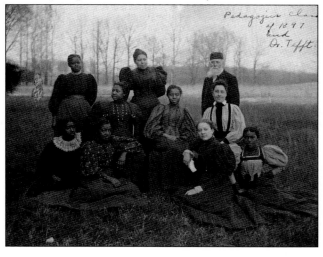

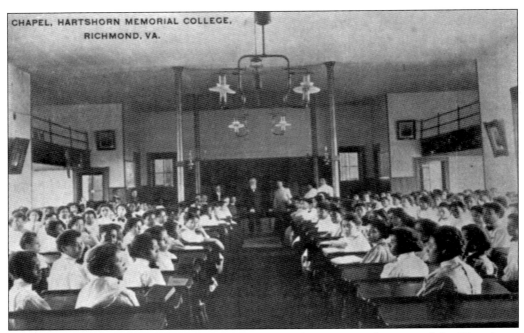

CHAPEL AND LAUNDRY DETAIL. Religion and spirituality were at the core of the Hartshorn experience, as were work ethic and cleanliness. Though Hartshorn had its own chapel and consistently conducted prayer and services, the students occasionally worshipped at VUU's Coburn Hall. Annual events included the Hartshorn and VUU joint worship service at Coburn Hall on George Washington's birthday and, at Christmastime, Hartshorn students went caroling around the neighborhood, notably at the VUU campus. The bridge between the two neighboring campuses, which crosses Lombardy Street over the railroad tracks, was built mainly as a safety measure because of student traffic between the two institutions.

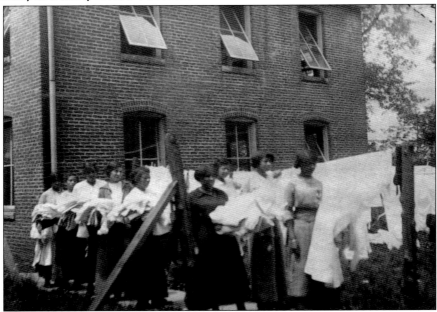

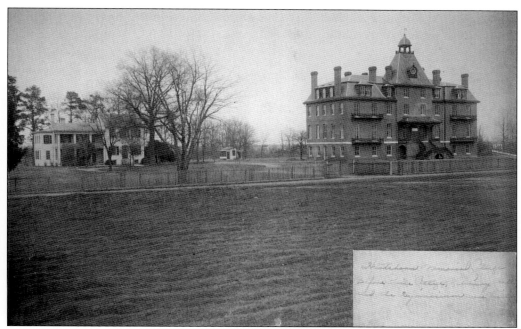

EARLY CAMPUS ON BOWE PLANTATION AND "INDUSTRIAL TEAM." Alumnae of Hartshorn would later become nostalgic about the "little brick cottage," one of the original Bowe Plantation buildings, apparently the old slave quarters. The cottage was used as a laundry and as a site for "Industrial Teams" competition, and it was a popular gathering place for many of the girls. There, usually away from the surveillance of the faculty, students could relax, gossip, and otherwise socialize in ways that might deviate from college decorum. Some of the rules could be intrusive and restrictive—there was a strict dress code, and students were not allowed to ride in streetcars or go dating on Saturday or Sunday. Offenders risked public humiliation at college assemblies where their names and transgressions would be publicized.

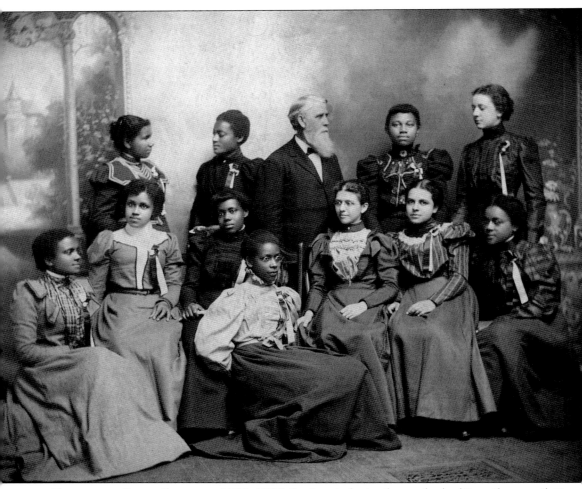

FACULTY AND SENIOR STUDENTS, 1898–1899. Senior students, those who had "run the gauntlet" for over two years and were on the verge of graduation, were accorded special consideration. Those posing for what is, in effect, a pre-graduation portrait, include, from left to right, (first row) Emma L. DeHaven, Eva Roberta Coles, Corina Cook, Daisy Burres, Mary E. Tefft, Mary E. Coleman, and Georgia E. Golding; (second row) Lula N. Thornton, Delilah F. Connor, professor Lyman Beecher Tefft, Alberta B. Cosby, and Lille V. Servant. Coles would soon become famous as a missionary to the Congo. The Hartshorn Memorial College seal displays a map of the African continent and the island of Madagascar with a rising sun in the background and inscribed words in Latin: "Sigillum colegii." Hartshorn ardently supported foreign missions, particularly to "the motherland."

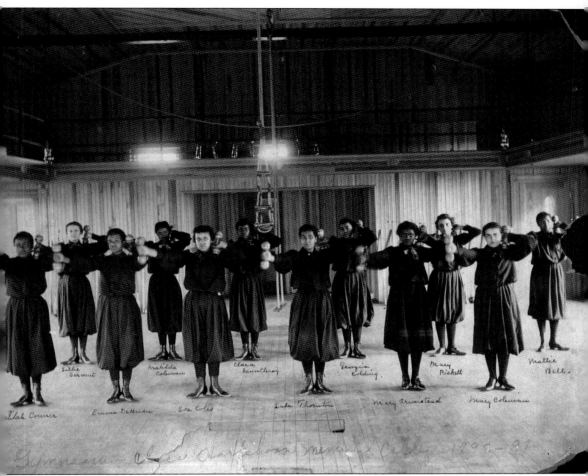

GYMNASTICS CLASS. Health and fitness was an integral part of the Hartshorn regimen. The students who seem to be experiencing some degree of strain (in contrast to the usually more sedate expressions in other photographs) are, from left to right, Delilah Connor, Lillie Servant, Emma DeHaven, Matilda Coleman, Eva Coles, Clara Fauntleroy, Lula Thornton, Georgia Golding, Mary Armistead, Mary Pickett, Mary Coleman, and Mattie Bell. The heavily buttoned-down and well-covered exercise outfits were in keeping with Hartshorn's regulation that the girls dress "for health and not for show," and to avoid "expensive dressing." Corsets came under a particularly vehement condemnation, with Prof. Lyman Beecher Tefft waxing eloquent over the physical harm and evils that come from corset-wearing. The girls were encouraged to participate in temperance activities and to use their persuasive powers to keep their boyfriends and fiancés away from alcohol.

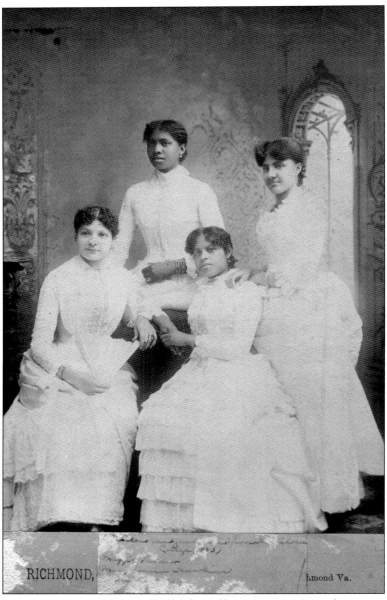

FIRST HARTSHORN GRADUATING CLASS, 1885. The college course at Hartshorn ran over a term of three years, after which successful candidates matriculated. The 1883–1884, 1884–1885, and 1885–1886 academic years brought the first program completion cycle to fruition, and the upcoming graduating seniors were photographed together in the fall of 1885. They are, from left to right, Mary Henrietta Miller Farrar, Mary Louise Hawkins, Lucinda James Kelley, and Sara Celestine Troy. The identical white dresses worn by the students, symbolic of purity, may have emblematized the White Shield League, a nationwide campus organization dedicated to inculcating chastity and sexual abstinence outside of marriage. The equivalent of the White Shield League at the all-male Virginia Union University was the White Cross League. The graduates pictured here received certificates; it was not until 1892 that Hartshorn students received degrees (bachelor of science).

Eva Roberta Coles Boone (right) and Rachel Tharps Boone (below). Though the name Hartshorn Memorial College has somewhat faded from history, and the last known alumna passed away in 2003, the school produced some outstanding women. Eva Roberta Coles was born in Charlottesville in 1880, graduated from Hartshorn in 1899, taught school for a while in Charlottesville, and married Rev. Clinton Caldwell Boone, a VUU graduate. In 1901, they traveled together to the Congo to work at the American Baptist Missionary Union mission at Palabala. Committed and courageous, she gained the confidence of the people there, who called her "Mama Bunu." Just before her tragic death on December 8, 1902, her last thoughts were to comfort her grieving husband. Reverend Boone remarried to Hartshorn alumna Rachel Tharps (class of 1911); she helped him administer a thriving mission and school in Liberia.

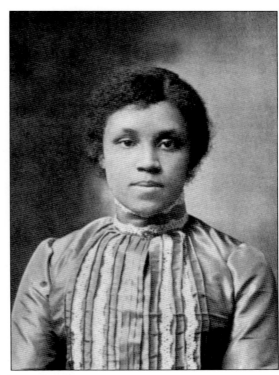

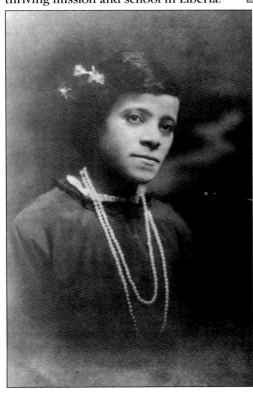

HARTSHORN MEMORIAL HALL. Very little remains in the way of physical evidence of the existence of Hartshorn Memorial College, which stood at Leigh and Lombardy Streets for 48 years (from 1884 to 1932). The buildings were obliterated in the 1930s and totally replaced by Maggie Walker High School, although a large memorial stone for Hartshorn was erected in front of the high school. On May 9, 2003, Ethel Marie Braxton Pitts, very likely the last surviving Hartshorn alumna, died at the age of 103. The college's name was commemorated with VUU's first women's dormitory building, Hartshorn Memorial Hall. This, the last of the Virginia Union buildings constructed with Virginia granite, was completed in 1934. It was first dubbed Morgan Hall to honor former American Baptist Home Mission Society president Thomas Jefferson Morgan, but Hartshorn alumnae Tossie Whiting and Leah Lewis successfully campaigned to change the name.

Four

IN THE VANGUARD OF FREEDOM
1941–1970

As the first African American president of Virginia Union University, Dr. John Malcus Ellison felt the pressure from the attention focused on him. After being a little-known scholar/minister from rural northeastern Virginia, he changed the face of Richmond by completing an incredible fundraising effort that brought the Belgian Friendship Building to campus; founded the Graduate School of Theology; and saw the beginnings of the civil rights struggle. That struggle reached its climax during the administrations of Dr. Samuel Dewitt Proctor and Dr. Thomas Howard Henderson. VUU students were decisively involved in many significant civil rights events during this tumultuous era. The arrest of 34 VUU students on February 22, 1960, during the Richmond sit-in protests, launched the decisive Campaign for Human Dignity. During the Henderson administration, the university undertook its most extensive building campaign since 1899. The main classroom building, Ellison Hall, was named for VUU's fourth president, while the new women's dormitory, MacVicar Hall, honored the first president. The student union was renamed Henderson Center, and the men's dormitory, Storer Hall, honors the fourth institution that merged into Virginia Union.

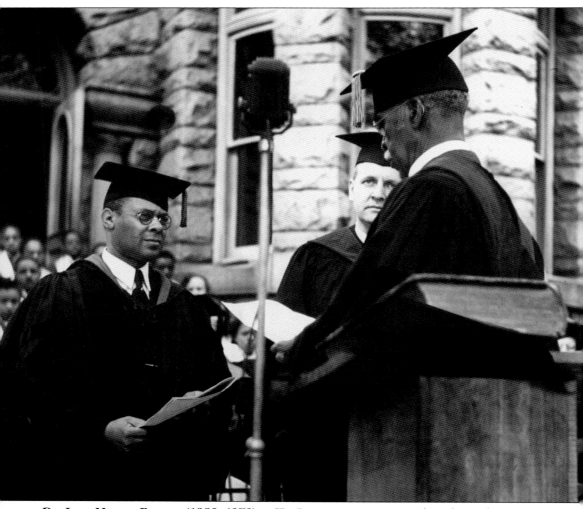

Dr. John Malcus Ellison (1889–1979) at His Inauguration. Pictured on the podium are Dr. Ellison (left); Dr. Theodore F. Adams, chair of the Virginia Union University Board of Trustees (center); and Dr. Joshua Baker Simpson. Ellison, the first African American to hold the office of president at Virginia Union, grew up in poverty in Northumberland County, Virginia. He studied at VUU from 1909 to 1917, earning a bachelor of arts degree in sociology. Embarking on both a pastoral and a teaching career, Ellison obtained his doctorate in Christian education and sociology from Drew University in 1933. After assuming the VUU presidency upon the retirement of Dr. William John Clark, Ellison was instantly faced with the task of raising the funds necessary to dismantle the Belgian Friendship Building, transport it from New York to the VUU campus, and reassemble it piece by piece. He accomplished this remarkable fundraising feat in a matter of months. Dr. Ellison then turned to successfully upgrading the VUU religious studies component to the Graduate School of Theology.

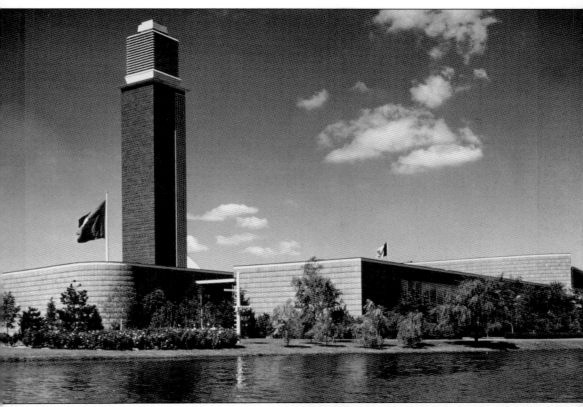

BELGIAN BUILDING AT THE NEW YORK WORLD'S FAIR, 1939. This building, originally designed by Henry Van de Velde as an avant-garde structure to be used as the Belgian Pavilion at the 1939 New York World's Fair, was to be disassembled and shipped back to Belgium. The structure included a graceful and imposing music tower with a carillon. Plans for returning the building to Belgium were disrupted by the Nazi invasion of the little kingdom in May 1940. The Belgian government-in-exile decided to award the building to an American college/university. Although 27 institutions competed, the Belgian government selected Virginia Union University to receive the building. That was the easy part; how was the building to be transported from New York to the VUU campus? (Courtesy of Jean St. Thomas.)

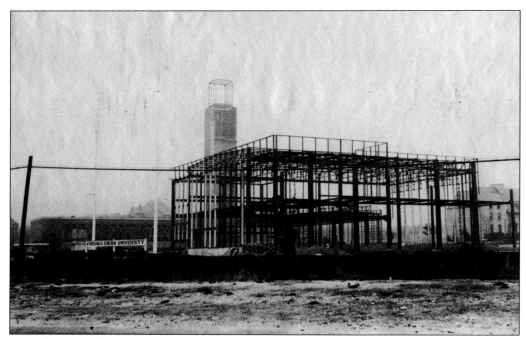

ASSEMBLING THE BELGIAN BUILDING AT VUU, 1941–1942. The task was daunting. First, $500,000 needed to be raised to pay for the dismantling; the transporting, piece by piece, of the building, tower and all, down US Route 1; and the reassembling of the building at the campus. VUU was fortunate to have Dr. John Malcus Ellison as its president. The tireless Ellison campaigned so successfully to raise the funds that the task was done by 1942. Architect Charles Thaddeus Russell, director of the VUU buildings and grounds, performed his last major service for VUU by supervising the entire operation. Russell's expertise enabled the parts to be put back together while preserving the building's architectural integrity.

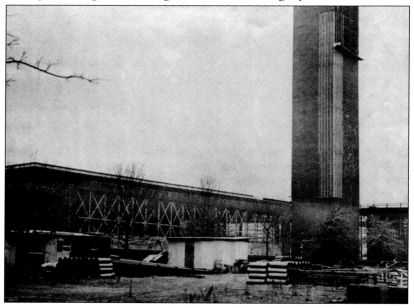

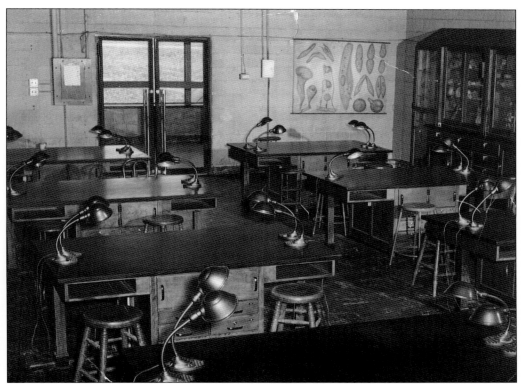

THE BELGIAN BUILDING ON CAMPUS. In 1942, the Belgian Friendship Building became an integral part of the VUU landscape and, over the 70 years of its existence on campus, has performed many significant functions. The southernmost portion of the building would house science classrooms and laboratories; the university library (the William John Clark Library) until 1997; a theater, classrooms, and studios for the revived fine arts department; and a physical fitness center for staff and students. A gymnasium occupied the northern portion of the building. During World War II and up until 1947, the Belgian Building functioned as a US Army induction center, and an estimated 161,000 individuals were processed through its halls.

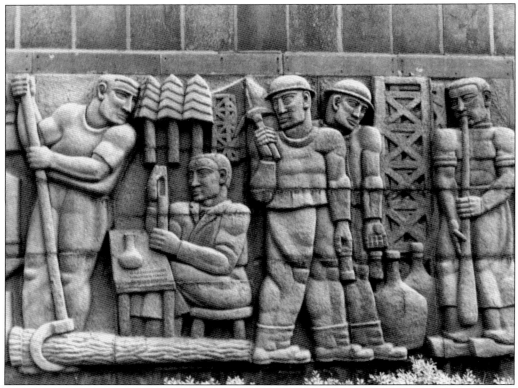

BELGIANS AT WORK. The Belgian Friendship Building contains two individual cultural gems that qualify as artistic masterpieces: the bas-relief sculptures *Belgians at Work* and *The Belgian Congo*. The *Belgians at Work* relief, located along the building's southern wall, is the most visible. It was carved in sandstone by artists Oscar Jespers and Henri Puvrez and is, by and large, a symbolic description of labor and occupations in 1930s Belgium.

THE BELGIAN CONGO. Located along the base of the Belgian Building, *The Belgian Congo* was the work of Arthur Dupagne, who specialized in art dealing with the Congo and other African subjects. It was controversial in that it seems to imply certain benefits of colonialism and depicts Congolese individuals in states of nakedness. In the 1940s, shrubs were planted along the base of the building, shielding the relief from public view from Lombardy Street. In this image, the relief is visible at far right through the window.

THE VANN TOWER. The Belgian Building's music tower was almost lost in the shuffle, as it was not part of the gift from the Belgian government. Jessie Vann, the widow of Robert Lee Vann, publisher of the *Pittsburgh Courier*, donated $25,000 to relocate the music tower to the VUU campus. Robert was a VUU alumnus, and Jessie served on the university's board of trustees. The tower was thus named in his memory. The Belgian government donated the original bells in the carillon to former president Herbert Hoover, who gave them to his alma mater, Stanford University.

"BELLS FOR PEACE" AND DIANNE NELSON WATKINS. Some 60 years after the carillon bells were sent to Stanford, Dianne Nelson Watkins, niece and adopted daughter of Dr. John Ellison, discovered this and founded the nonprofit organization Bells for Peace to fund the carillon's reinstallation in the Belgian Building.

THE WILLIAM JOHN CLARK LIBRARY. Establishing a viable library had long been a priority of the school administration. Dr. George Rice Hovey had worked hard to augment the library collection, which was housed at Coburn Hall from 1899 until 1942. After Dr. Hovey's departure and until the appointment of Wallace Van Jackson (1900–1982) as librarian in 1927, library development stagnated. Van Jackson, a VUU graduate, was a civil rights activist who successfully challenged voter discrimination in Atlanta during the 1940s. He wrote a comprehensive report on library facilities and the need for additional facilities and staff to adequately accommodate growing library collections. In no small part because of the Van Jackson report, a large amount of space was set aside in the Belgian Building for a library that would be named in honor of President Clark.

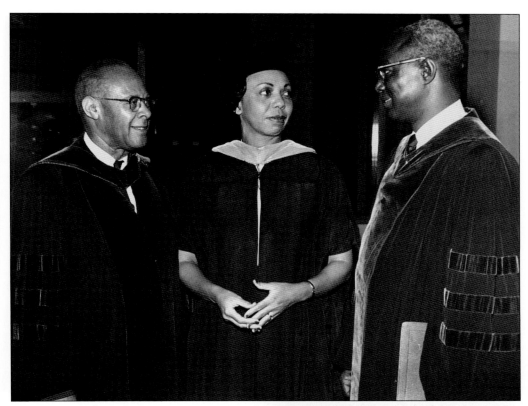

VERDELLE VANDERHORST BRADLEY AND DR. WALTER O. BRADLEY SR. Wallace Van Jackson left Virginia Union in 1941 to take a librarian position at Clark Atlanta University. Shortly thereafter, the William John Clark Library was established in the Belgian Building at VUU. In 1946, Verdelle Vanderhorst Bradley became the head librarian; she stayed at the helm for years, pioneering an oral history project on civil rights in Virginia. She was married to Dr. Walter Oswald Bradley, a biology professor from Florida who joined VUU as a professor in 1945, received his doctorate from the Catholic University of America in 1950, and became chair of the natural sciences and mathematics department in 1952.

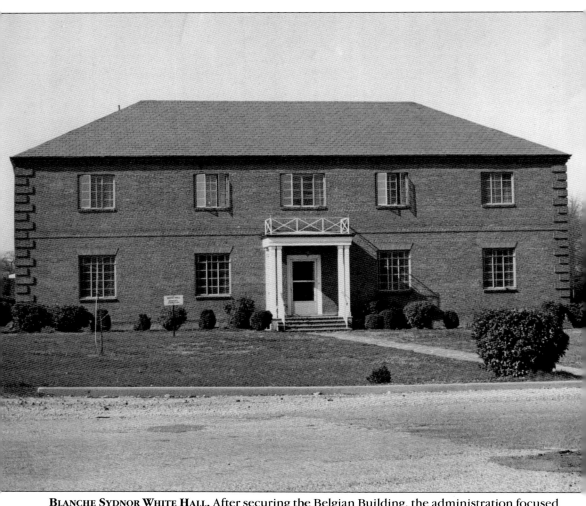

BLANCHE SYDNOR WHITE HALL. After securing the Belgian Building, the administration focused on the construction of Blanche Sydnor White Hall, which was erected in 1953 at the far northern edge of the campus bordering Graham Road. The Southern Baptist Convention's Women's Missionary Union donated the initial funding of $70,000. The hall's original purpose was to lodge women destined for foreign missions activities, and a special director, Rebekah J. Calloway, was hired to administer the program. The building's namesake, Blanche Sydnor White (1891–1974) was the Women's Missionary Union's executive secretary, a member of the Virginia Union University Board of Trustees, and a prodigious author of books and pamphlets on religion and religious history. The building later housed the school's African and Oceanic art collections, the offices of the athletic department, and the music department.

ADM. SAMUEL GRAVELY (1922–2004). Samuel Lee Gravely Jr. was born in Richmond, Virginia, and enrolled at VUU in 1940, but he enlisted in the US Naval Reserves in September 1942. He entered the officer training program and, in 1944, was commissioned at the rank of ensign—the first such US Naval Reserves commission for an African American. He resumed his studies at VUU in 1946 and graduated with a bachelor of arts in history in 1948. During the Korean War, Gravely served aboard the battleship USS *Iowa* at the rank of lieutenant, JG. During the Vietnam War, having risen to the rank of captain, he commanded the USS *Falgout*. As rear admiral (in 1971), then as vice admiral (in 1976), he became the first African American flag officer in the country. He commanded the US Third Fleet at Pearl Harbor, Hawaii, from 1976 to 1978. Gravely is pictured above at right, and at center below, with Dr. John Holoman (left) and Dr. Allix B. James.

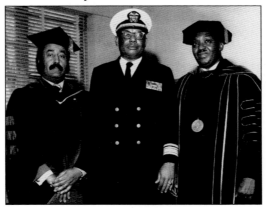

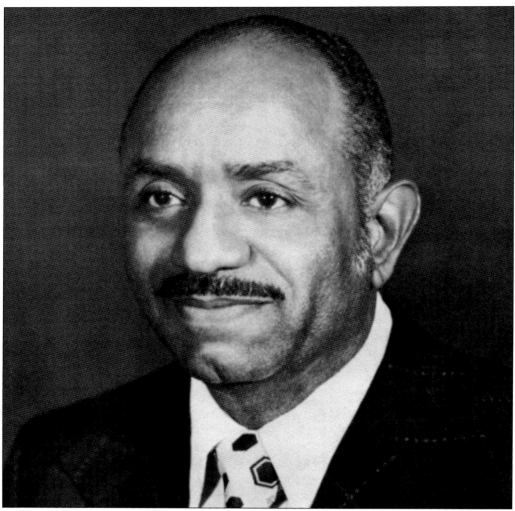

HOWARD ST. CLAIRE JONES JR. (1921–2005). Jones was the most prolific of the inventive geniuses nurtured at Virginia Union. Dr. Jones, who graduated from Virginia Union in 1943 in mathematics and physics, went on, 30 years later, to receive his master of science degree in electrical engineering at Bucknell University. After a stint in the military and at the National Bureau of Standards, Jones joined the Harry Diamond (Military) Laboratory in Adelphi, Maryland, where he spent the rest of his lengthy career until his retirement in 1980. Jones specialized in microwave/radar technology, and his astounding 31 registered patents rank him as a significant factor in the United States' victory in the Cold War with the Soviet Union and as one of the most productive technological innovators that the United States has ever produced. In 1999, he was elected to the National Academy of Engineering.

LUCILLE MURRAY BROWN (RIGHT) AND JANET JONES BALLARD (BELOW). The transformation of the all-male Virginia Union University into a coeducational institution inevitably produced many outstanding female graduates. Noteworthy are Lucille Murray Brown and Janet Jones Ballard, who matriculated in science and sociology, respectively. Ballard received a master of education from Virginia State and was one of Richmond's earliest civil rights activists. She had quietly integrated the Thalhimers Department Store beauty salon. Ballard was named the Richmond Urban League's first female director and 22nd supreme basileus of the Alpha Kappa Alpha sorority's national organization. Dr. Lucille Murray Brown (class of 1950) went to graduate school at Howard; became principal of Armstrong High School in Richmond, assistant superintendent for secondary education, superintendent for the Richmond Public Schools system, and chair of the academic affairs committee of VUU's board of trustees.

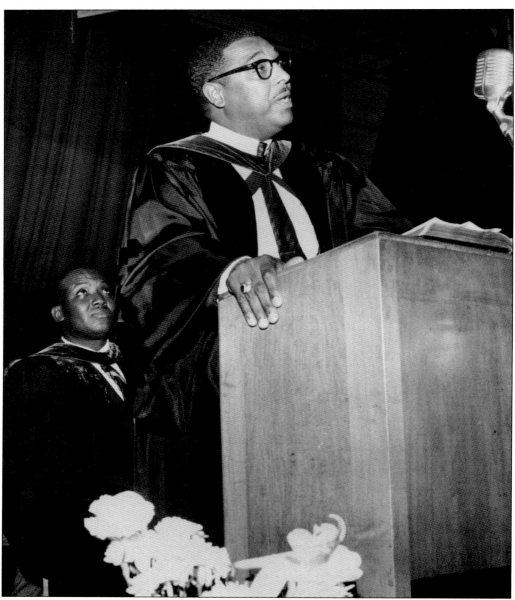

DR. SAMUEL DEWITT PROCTOR (1921–1997). Dr. John Malcus Ellison was succeeded by one of VUU's most ebullient and dynamic presidents. Proctor was born in Norfolk, Virginia, and—according to his own testimony—underwent a "stormy" two years at Virginia State College. He experienced a calling to the ministry and entered Virginia Union University as a junior. He pursued his graduate studies at Crozer Theological Seminary, where he forged a lifelong friendship with Martin Luther King Jr., and at Boston University. At VUU, Proctor became professor of New Testament studies, dean of the School of Theology, and vice president of VUU. Tuition shortfalls brought about by the Korean War put the university $90,000 in debt. Proctor arranged for a $50,000 loan from the American Baptist Home Mission Society, forestalling bankruptcy; he then helped repay the loan in an astonishingly short time, retired the rest of the debt, and pulled VUU into a period of expansion and prosperity.

NEWMAN HALL. By far the most significant expansion project of the Proctor administration was the building of Ora Johnson Newman Hall as a female dormitory to supplement Hartshorn Hall. Ora Johnson Newman was a Virginia Union alumna who spent her professional life as an educator in the Richmond Public Schools system.

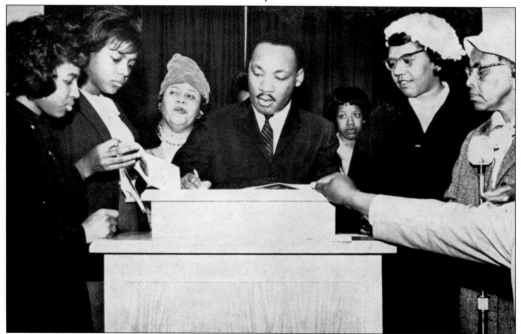

DR. MARTIN LUTHER KING JR. AND VIRGINIA UNION. Dr. King, shown at the podium in Coburn Chapel, belongs, in the deepest sense, to everyone. But VUU takes pride in its connection with Dr. King, whose friendship with VUU president Samuel Proctor proved enduring and whose speeches at Coburn and Barco-Stevens Halls inspired the 1960s generation of students and instructed them in the virtues and techniques of nonviolence.

DR. WYATT TEE WALKER. Walker is eminent among the civil rights leaders who emerged from VUU and one of its most prominent ministers and scholars. Walker graduated from Virginia Union in 1950 with a bachelor of science degree. In 1953, he completed his graduate studies at the VUU School of Theology, earning a master's degree in divinity. In 1975, he obtained his doctorate in theology from the Colgate-Rochester Divinity School. On March 7, 1960, Walker became the focus of national attention when he was arrested for attempting to desegregate the public library in Petersburg, Virginia. Shortly thereafter, Walker was made chief of staff to Dr. Martin Luther King Jr. Walker also served as executive director of the Southern Christian Leadership Conference from 1960 to 1964 and was at the heart of nearly every major initiative of the civil rights movement. From 1967 to 2004, he was chief minister at the Canaan Baptist Church in Harlem.

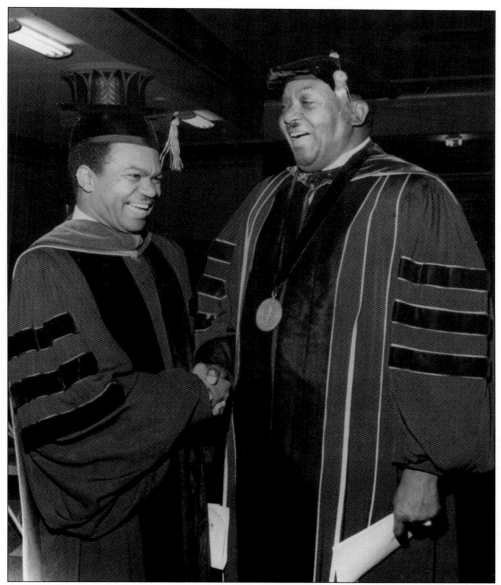

WALTER FAUNTROY. Fauntroy (at left) studied for a bachelor's degree in history from Virginia Union, from which he graduated in 1955; and matriculated at Yale Divinity School, earning a bachelor of divinity degree in 1958. From 1960 to 1971, Fauntroy was director of operations for the Southern Christian Leadership Conference in Washington, DC, and as such, bore primary responsibility for organizing the 1963 March on Washington for Jobs and Freedom. His administrative abilities were so manifest that Dr. Martin Luther King Jr. asked that he coordinate the Selma-to-Montgomery (1965), Mississippi Freedom (1966), and Poor Peoples' (1968) Marches. An unyielding advocate for home rule for Washington, DC, he served on the capital's first city council from 1967 to 1969 before being elected as the district's semiofficial member in the House of Representatives, a position he held until 1990. In 1984, Fauntroy and fellow Unionite Randall Robinson were arrested for illegally protesting South Africa's apartheid policy at the South African ambassadorial residence.

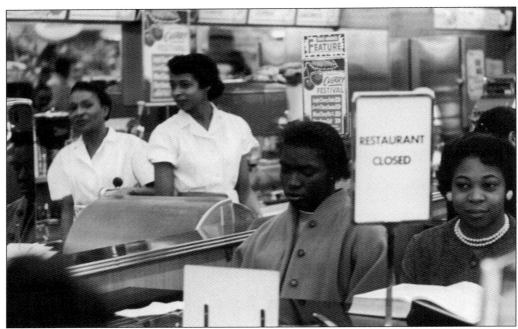

VUU Students' Sit-In At Woolworth's Counter and Protest in Richmond Room. The years of repression, injustice, and frustration came to a climax in Richmond, Virginia, as word of the Greensboro, North Carolina, sit-in spread to Virginia. Frank G. Pinkston and Charles M. Sherrod, student leaders at Virginia Union, conferred with university president Samuel Proctor, who tacitly acquiesced in their plans. On February 20, 1960, some 200 VUU students marched to downtown Richmond to occupy lunch counter seats in establishments such as Woolworth's, Miller & Rhoads, and Thalhimers, where segregation was practiced. It was a Saturday, and the stores simply closed their facilities without incident. But on Monday, February 22, the students marched downtown once again, and a dramatic confrontation took place at the lunch counter and the Richmond Room Restaurant of Thalhimers Department Store. (Both, courtesy of the Anderson Collection, Valentine Richmond History Center.)

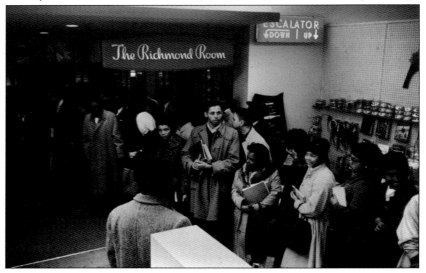

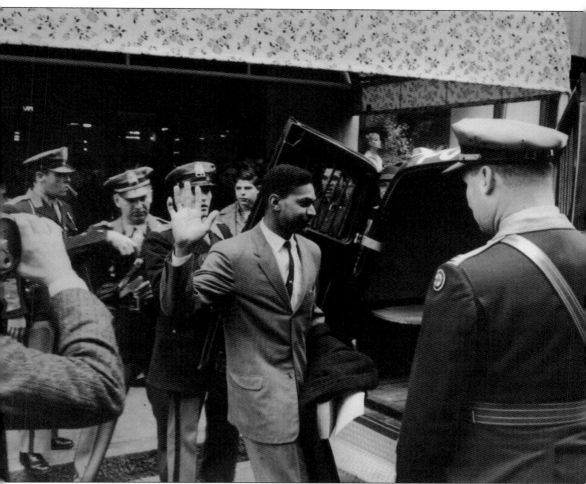

LEROY M. BRAY JR. ARRESTED. The VUU students protesting segregation at Thalhimers Department Store were approached by store managers and asked to leave or else they would be arrested for trespassing. Some of the seated students left, but 34 did not, and Richmond city police units soon arrived. Some of the officers brought police dogs, and mounted patrolmen were outside. Young Bray was the first man arrested. He was led to the patrol wagon and, like the 33 who followed him, was booked and spent a brief time in a cell before being released on bond. A number of people and institutions combined to bail out the "VUU 34" students: the local NAACP chapter; the graduate chapter of Alpha Kappa Alpha sorority (under Dr. Laverne Byrd Smith); and Dr. Allix B. James, who offered his house as collateral. Bray entered the ministry and has served for over 38 years. (Courtesy of the Anderson Collection, Valentine Richmond History Center.)

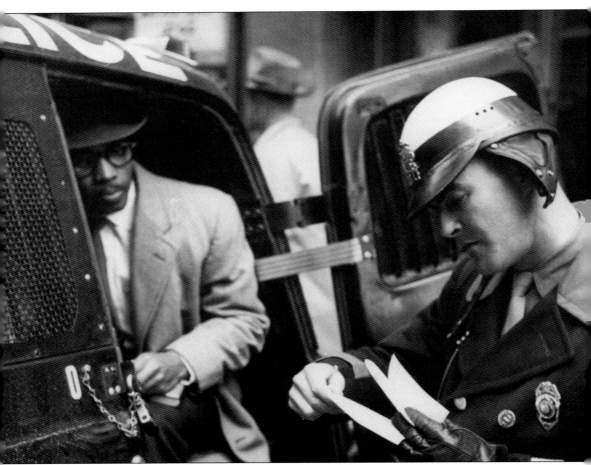

FRANK G. PINKSTON PLACED INTO THE PADDY WAGON. Rev. Frank George Pinkston Sr. was a theological student and assistant football coach at Virginia Union when he was arrested as a "VUU 34" leader at the sit-in at Thalhimers Department Store. Pinkston became a charter member of the SNCC (Student Nonviolent Coordinating Committee), and left VUU with a master's degree from the school of theology in 1961. The *Richmond Times-Dispatch* account of the sit-in records his defiance as he was being led to the wagon through the crowd, shouting and challenging them to continue the struggle. Pinkston returned to his native Florida, and in 1963, at Ocala, Florida, he led a protest/boycott campaign similar to Richmond's Campaign for Human Dignity. In Ocala, he ministered, taught school, and continued the civil rights struggle. A stretch of US Highway 27 was named the Frank George Pinkston Sr. Memorial Highway in honor of the charismatic pastor, who passed away in 1973. (Courtesy of the *Richmond Times-Dispatch*.)

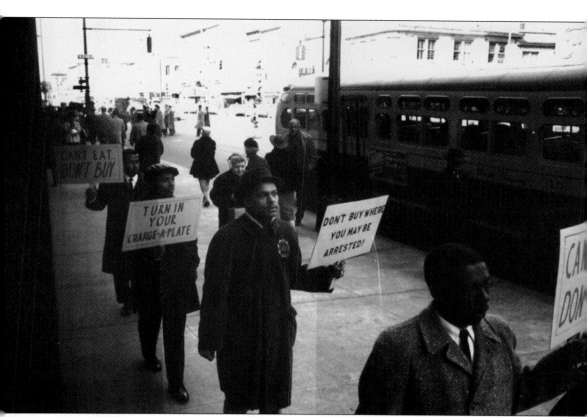

VUU STUDENTS PICKET ALONG BROAD STREET. Upon their release, the "VUU 34" were driven in a motorcade to the Eggleston Hotel at Second and Clay Streets and feted as heroes. This immediately launched the Richmond Campaign for Human Dignity, in which VUU and the surrounding community combined to protest, boycott, and otherwise (nonviolently) assail the entire Jim Crow apparatus in Richmond. Students picketing, carrying signs, and marching up and down Broad Street became a daily occurrence. By early 1961, the campaign had brought many establishments to their knees. The major department store chains, the People's Drug Stores, and the Greyhound and Trailways bus terminals all surrendered and dismantled their segregationist policies. The "VUU 34" were convicted of trespassing but appealed to the Supreme Court, which, in 1963, in the case of *Raymond B. Randolph et al. v. Virginia*, declared their arrests unconstitutional. (Courtesy of the Anderson Collection, Valentine Richmond History Collection.)

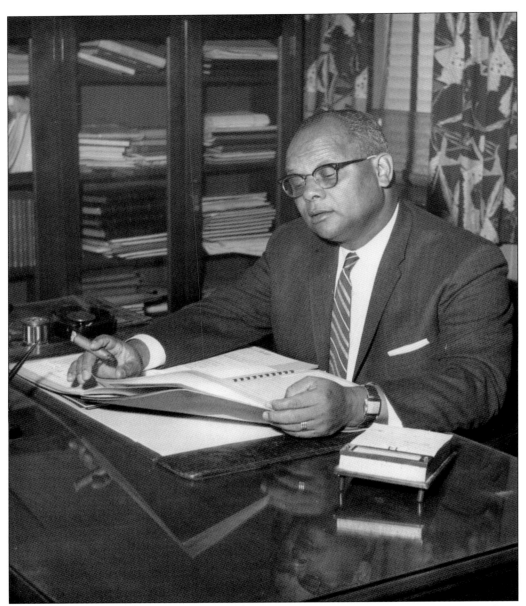

DR. THOMAS HOWARD HENDERSON (1910–1970). Thomas Howard Henderson graduated from VUU in 1929 with a bachelor of science degree. At the University of Chicago, he earned his master's (1936) and doctoral (1946) degrees. Dr. John Malcus Ellison appointed Henderson as dean in 1941. Henderson was designated by the board of trustees as the first Virginia Union president who had not served in the ministry of the Baptist Church. Henderson and Virginia Union played a significant, though understated, role during the revolution for human rights that occupied the entire period of the Henderson administration (1960–1970) and brimmed over for years. It is an ironic indication of the rapid pace at which events and ideas could move during the 1960s that a sincere advocate for change such as Henderson ultimately became a target for radical student protest towards the end of the decade, for being too moderate. Radical students staged a campus takeover in 1968.

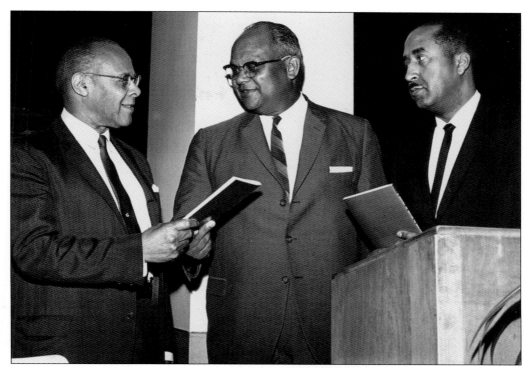

DR. JOHN MALCUS ELLISON (LEFT), DR. THOMAS HOWARD HENDERSON (CENTER), AND DR. JOHN L.S. HOLLOMAN JR. (ABOVE); AND DR. HENDERSON (LEFT), TOMMYZEE HENDERSON (CENTER), AND DR. HOLLOMAN (BELOW). Dr. John L.S. Holloman Jr., chair of the university's board of trustees from 1961 to 1982, and Dr. Henderson shared a sense of family at their alma mater. In 1965, Dr. Henderson was a proud father who personally bestowed the VUU graduation diploma upon his daughter, Tommyzee. Dr. Holloman, son of a VUU alumnus, graduated from VUU in 1940. In 1943, he received a medical degree from the University of Michigan and entered the armed forces, achieving the rank of captain. After founding and cochairing the medical committee on civil rights, he took an active role during the marches of the 1960s as an attending physician. Holloman was president of New York City's public hospital corporation from 1974 to 1977.

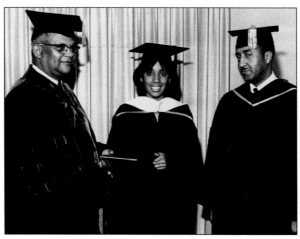

REV. CHARLES M. SHERROD. Sherrod (center) was among the five charter members of the Student Nonviolent Coordinating Committee from VUU (the others were Frank Pinkston, Laura Greene, Elizabeth Johnson Rice, and Virginius Bray Thornton III), and went on to participate in the Freedom Rides and to spearhead the Albany (Georgia) Movement in 1961 and 1962. After settling in Albany, he served on the city commission from 1976 to 1990.

REV. REGINALD M. GREEN. As a VUU student, Green participated in the 1960 Richmond sit-ins. In 1961, he was one of three Virginia Union students who boarded a Trailways bus in Richmond to go on the Freedom Rides. He was arrested in Jackson, Mississippi, and imprisoned in Parchman Penitentiary. He later served as longtime pastor of Walker Memorial Baptist Church in Washington, DC.

ELLISON HALL. Ellison Hall accommodated humanities and social science classes and offices, the office of the registrar and financial aid, the IT center, and the center for undergraduate studies. The auditorium was named after the late Dr. Limas Dunlap Wall, chair of the science department. On May 18, 1968, the structure was renamed John Malcus Ellison Hall in honor of the fourth VUU president.

HENDERSON CENTER (STUDENT UNION). Henderson Center was first called the Student Union, and in order to build it, the president's house had to be transported in one piece to the corner of Brook and Graham Roads. The name of the student union was changed to honor VUU's sixth president, Dr. Thomas Howard Henderson.

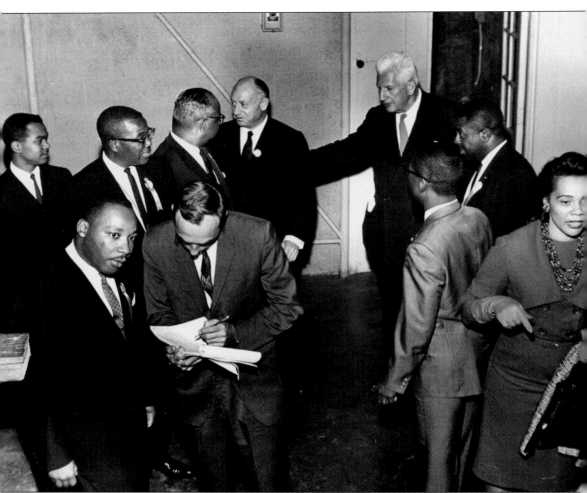

Dr. King's Last Visit to the Virginia Union Campus. Dr. Martin Luther King Jr. had a long-standing acquaintance with Virginia Union. While he was still a theological student at Crozer Theological Seminary, he crashed at VUU with his good friend, Dr. Samuel Dewitt Proctor, en route back to Pennsylvania. King and Proctor remained close friends throughout the years of the civil rights struggle, and King visited the campus on several occasions. In this image of his last visit to the VUU campus, at Barco-Stevens Hall, King fields a reporter's question. Coretta Scott King (at far right) seems focused on something in the distance. Third from left in the background is VUU president Thomas Henderson, and to his left are US senators Jacob Javits (from New York) and Paul Douglas (from Illinois), and Dr. Ralph Abernathy.

STORER HALL AND MACVICAR HALL. Student housing has always been an issue. At VUU, when demand outstripped resources, the first dormitory, Kingsley Hall, had to be supplemented by Huntley Hall. In 1934, coeducation necessitated the building of Hartshorn Hall, and as women became a larger part of the college population, White Hall (1953) and Newman Hall (1960) were added. The new men's and women's dorms built in the mid–1960s were Storer and MacVicar Halls, respectively. The former was named for the Harpers Ferry college that had just officially merged into VUU, and the latter was named after the first president of Virginia Union.

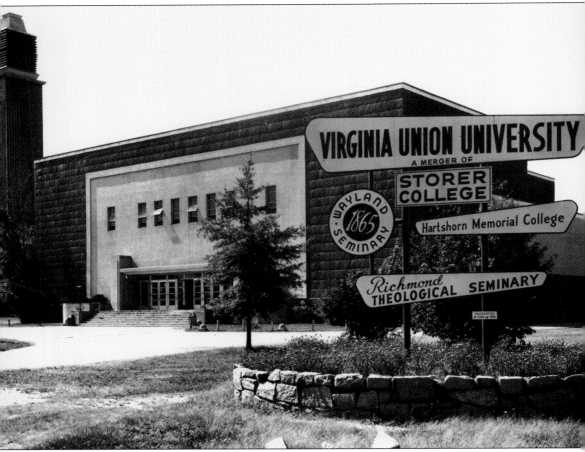

BARCO-STEVENS HALL AND THE ICONIC UNION SIGNS. In 1964, the final component of the "union" of Virginia Union University was added when venerable Storer College, formerly of Harpers Ferry, West Virginia, joined Richmond Theological Seminary, Wayland Seminary, and Hartshorn Memorial College. The circumstances were regrettable that Storer College, which had served to educate African Americans from 1865 until 1956, should have been a victim of the case that opened up hope for so many, *Brown v. the Board of Education.* To segregationist authorities in West Virginia, Storer had long been a thorn in their side. After the Supreme Court declared segregation in education to be unconstitutional, the powers that be used the decision as a shameless excuse to end state funding for Storer. Without this financial lifeblood, the college had to discontinue classes and shut its doors in 1956.

Five

STORER COLLEGE
1865–1955

Storer College, the last of the four institutions that form Virginia Union University, did not become part of VUU until 1964. It was a process 99 years in the making; in October 1865, Freewill Baptist minister Dr. Nathan Cook Brackett started a school at Harpers Ferry, West Virginia, for freed African Americans. Brackett's efforts were augmented by a generous contribution from wealthy Maine businessman John Storer, and the institution was named in Storer's honor. As the only historically black college in the state of West Virginia for many years, Storer produced students and alumni who made significant contributions, including Nnamdi Azikiwe, J.R. Clifford, Donald Redman, Joseph Jeffrey Walters, and John Francis Wheaton. After the *Brown v. the Board of Education* ruling mandated school integration, West Virginia withdrew vital subsidies to Storer and, consequently, the college closed in 1955; its records, endowment, and alumni associations merged into VUU.

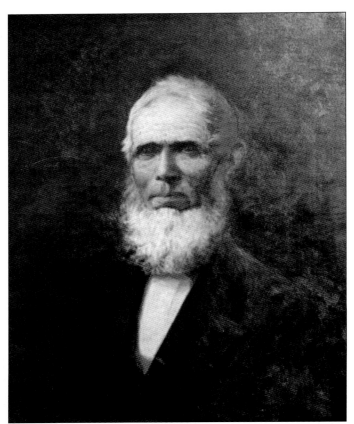

JOHN STORER. As advocates for the betterment of the lot of former slaves fanned out through the former Confederacy, the newly minted state of West Virginia was nearly forgotten. But Dr. Nathan Cook Bracket, of the Freewill Baptist Church, journeyed to the town of Harpers Ferry and established a small school for the freed population in October 1865. As word spread, prospective students arrived from all directions. Unable to cope with the resources at hand, Brackett issued a call for help, and wealthy New Englander John Storer responded with a $10,000 gift. Storer died a few days later, and Brackett named the institution after him. (Courtesy of West Virginia and Regional History Center, WVU Libraries.)

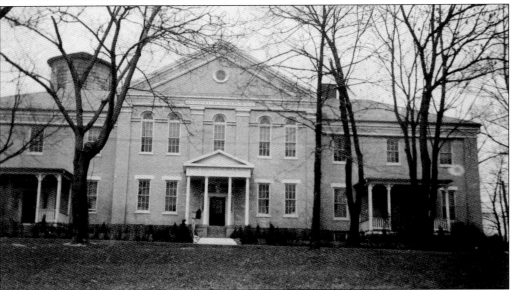

ANTHONY HALL. This functioned as Storer College's principal building. Dr. Brackett administered Storer College as its first president until 1897. (Courtesy of West Virginia and Regional History Center, WVU Libraries.)

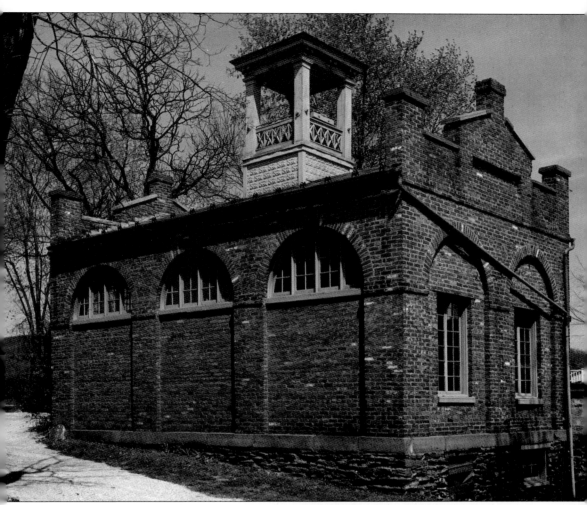

JOHN BROWN'S FORT. This fort was part of the Storer College campus and legend. This old fire engine house was seized on October 16, 1859, by John Brown and his men during their ill-fated uprising to destroy slavery. This was where Brown held out until Marines stormed in and captured him; he was hanged on December 2, 1859. On May 30, 1881, it was the site of one of Frederick Douglass's most famous speeches. Douglass had become a trustee of Storer College. He spoke eloquently and at length of the meaning and historical significance of Brown's raid. The fort was dismantled, rebuilt, and moved several times before it was finally purchased by the college in 1909 for $900. After Storer College closed, the National Park Service acquired the property in 1960; it is now a historic site. (Courtesy of West Virginia and Regional History Center, WVU Libraries)

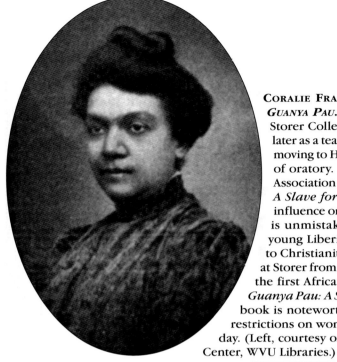

CORALIE FRANKLIN COOK (1858–1942) AND *GUANYA PAU.* Coralie Cook graduated from Storer College in 1880, returning two years later as a teacher of English and speech before moving to Howard University to serve as chair of oratory. She helped found the National Association of Colored Women and authored *A Slave for Life: a Story of Long Ago.* Her influence on another famous Storer alumnus is unmistakable. Joseph Jeffrey Walters, a young Liberian of the Vai Nation, converted to Christianity, went to America, and studied at Storer from 1883 until 1888. In 1891, he was the first African to publish a novel in English: *Guanya Pau: A Story of an African Princess.* The book is noteworthy for its condemnation of the restrictions on women by the African society of his day. (Left, courtesy of West Virginia Regional History Center, WVU Libraries.)

Guanya Pau: A Story Of An African Princess

Joseph Jeffrey Walters

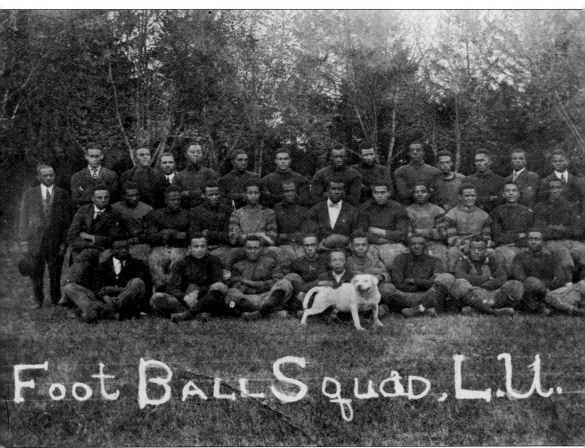

STORER FOOTBALL SQUAD. Although Storer College focused on academics, it did not totally neglect athletics. Though the school was never a sports powerhouse, Storer, with athletic teams dubbed the Golden Tornado, offered football, baseball, and women's and men's basketball. Storer's most famous football player never made a career in sports. Benjamin Nnamdi Azikiwe (1904–1996) was born in Zungeru, Nigeria, and enrolled at Storer in 1925. Afterward, he continued his education at Howard University, Lincoln University, the University of Pennsylvania, and Columbia University. Upon returning to Nigeria, Azikiwe embarked on careers in journalism and anticolonialist politics. He helped to spearhead the independence movement and gained international prominence. From 1963 to 1966, he held office as the first president of the Republic of Nigeria. In a 1927 speech, he praised his experience at Storer, saying that "the college stands for high ideals . . . it stands for all that is good, noble, and lofty in life." (Courtesy of West Virginia Regional History Center, WVU Libraries.)

Dr. Richard I. McKinney (1906–2005). Dr. McKinney (left) studied at Morehouse College and Andover Newton Theological School before being awarded a doctorate at Yale University in 1937. He came to Virginia Union University in 1935 as a professor of religious studies. McKinney so impressed president Dr. John Malcus Ellison that in 1942, he was appointed to be the first dean of the graduate school of theology. In 1944, McKinney became the first African American president of Storer College, a position he held until 1950. Dr. McKinney successfully faced an uphill battle against bigotry; on the night of his arrival, the Ku Klux Klan burned a cross on campus. From 1950 to 1978, Dr. McKinney took a position as founding chair of the philosophy department at Morgan State University and came back to Virginia Union for a year as acting vice president for academic affairs. (Courtesy of West Virginia Regional History Center, WVU Libraries.)

Six

AN ENDURING MISSION
1970–2015

The death of Dr. Thomas Henderson brought Dr. Allix Bledsoe James to the presidency of Virginia Union from 1970 to 1979. During the administration of Dr. David Thomas Shannon (1979–1985), the British American Tobacco Company was persuaded to donate its office building at Leigh and Lombardy Streets to the university. This became the C.D. King Building. The administration of Dr. S. Dallas Simmons ushered in the most notable physical expansion on campus since the 1960s. President Simmons was followed by Dr. Bernard Wayne Franklin (1999–2003) and Dr. Belinda Childress Anderson (2003–2009). Virginia Union became the first historically black university in the United States to install a campus-wide wireless infrastructure. In an event reminiscent of the great nonviolent protests of the 1960s, Virginia Union students picketed Lombardy Street in December 2001 in the course of a successful campaign by the university to overcome political opposition to a redesign of Lombardy Street through the campus as a measure meant to ensure the safety of its students and faculty. The administration of veteran educator Dr. Claude Grandford Perkins, who assumed office in 2009, forged new links with the greater community and revitalized the physical campus and academic environment: An attractive wrought-iron fence was built to encircle the campus; the fine arts and ROTC programs, choir, and band were revitalized, a fitness center was established; and ground was broken for the future living and learning center.

Dr. Allix Bledsoe James. Dr. James was born in Marshall, Texas. The long-standing friendship between James's father and Dr. John Malcus Ellison factored in the decision of Allix James to pursue his undergraduate degree at VUU. At Union Theological Seminary in Virginia, he received a master's (1949) and doctorate (1957) in theology. His professional career at Virginia Union began in 1947 when he was appointed by Ellison to the post of instructor in biblical studies. In 1950, James was named dean of students. In 1956, he was appointed to the deanship of the school of theology. When Dr. Thomas Henderson became president of VUU, Dr. James was named vice president. On February 22, 1960, James put his house and property up to help secure bail money for the "VUU 34." In 1970, James became VUU's seventh president, serving until 1979, and presided over the establishment of the Sydney Lewis School of Business.

THE COBURN HALL DISASTER. In the early morning hours of May 16, 1970, someone noticed smoke coming from the Coburn Hall building. The fire, which spread at a rapid rate, had engulfed the entire roof within 10 minutes, and by the time firefighters arrived around 2:00 a.m., the devastation was complete. Though the Virginia granite walls proved indestructible, the interior was totally gutted.

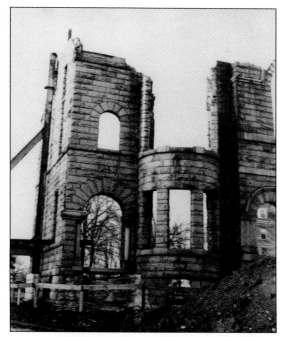

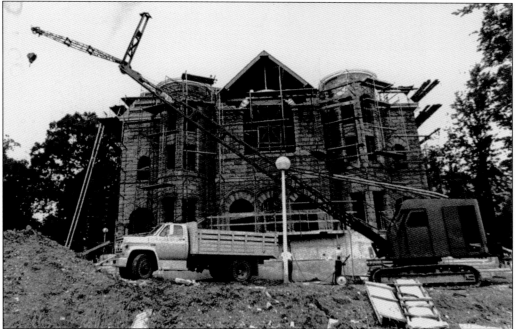

COBURN HALL REBUILT. Campaigns for rebuilding were launched almost immediately, but the building itself was uninsured and would not be used for assembly and worship for another generation. Two decades of soliciting donations, massive renovations, and fervent prayers finally reaped dividends for the VUU family when, on Opening Convocation Day (November 22, 1991), they celebrated the restoration of Coburn Hall, and the chapel itself was reconsecrated as the Allix B. James Chapel.

Dr. John Andrew Watson Jr. (1920–2006). Watson served as a faculty member for over 57 years (from 1948 to 2006), the longest tenure of any teacher at VUU. A World War II veteran who took part in the "Red Ball Express," Watson taught foreign languages and was well known (and sometimes dreaded) by students for his thorough attention to detail. He earned his bachelor's degree in Romance languages from Howard; his master's from the University of Paris; and his doctorate from the Catholic University of America. He coached the tennis team from 1959 until 2002 (in the course of his off-campus community service, he was instrumental in the instruction of a young man named Arthur Ashe) and the chess team.

SYDNEY AND FRANCES LEWIS AND THE SCHOOL OF BUSINESS. Sydney Lewis and his wife, Frances Aronson, who founded the firm of Best Products, Inc., and gained fame as avid art patrons, became affiliated with VUU through Sydney's participation on the board of trustees, fundraising, and donations. The philanthropy of the Lewises (pictured at right in the second row) helped transform the Department of Commerce into a fully accredited school, the Sydney Lewis School of Business.

DR. DOROTHY NORRIS COWLING (1913–2009). Dr. Cowling was the first woman to serve as a chief executive at VUU, holding the position of acting president from June to October 1979 after Dr. Allix James retired. Cowling received her bachelor's in elementary education from Virginia State College, her master's from Columbia, and her doctorate from Lehigh. She is especially noted for her commitment to the welfare of students as individuals and her strengthening of VUU's federal grants programs.

Dr. David Thomas Shannon (1933–2008). Dr. Shannon was a 1954 VUU graduate who started his career as a minister at the age of 16 and earned both a bachelor of arts and a bachelor of divinity degree while studying at Virginia Union. He earned his master's degree from the Oberlin Graduate School of Theology, plus a doctorate from the University of Pittsburgh and a doctorate in divinity from Vanderbilt University. As a member of the faculty of VUU for many years, he distinguished himself as one of Virginia Union's most erudite and accomplished teachers, exerting a steady, calming influence during the civil rights upheavals of the 1960s. From 1960 to 1969, he pastored at Richmond's Ebenezer Baptist Church. Dr. Shannon departed to become associate professor of religion at Bucknell University; distinguished professor for the Hartford Seminary Foundation; and, in 1973, the first African American dean of the Pittsburgh School of Theology. In 1979, he accepted the call and became the eighth president of VUU.

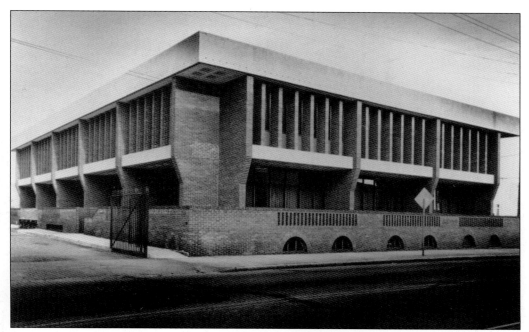

THE C.D. KING BUILDING. A major legacy of the Shannon administration was the 1981 finalization of the acquisition of the C.D. King Building. Located at the southwestern corner of Leigh and Lombardy Streets, the building had been the headquarters for the British American Tobacco Company. After the company relocated, the vacant building came to the attention of Clarence Lee Townes Jr.

CLARENCE LEE TOWNES JR. Townes graduated from Virginia Union in 1948 with a bachelor of science degree in commerce. In Richmond, he had a long career in local business and politics. Through connections with various civic and business leaders, Townes helped arrange for the former British American Tobacco Company building to be donated to VUU for $1. The building was named for former trustee board member Clarence D. King.

Dr. S. Dallas Simmons. VUU's ninth president first attended North Carolina Central University, where he earned bachelor's and master's degrees in business administration. At Duke University, he earned a doctorate in management in higher education. Simmons served with IBM as a marketing executive; in the Gerald Ford administration as special assistant; as assistant to the vice chancellor and chancellor at North Carolina Central; and as president of St. Paul's College in Lawrenceville, Virginia, before officially taking the helm at Virginia Union on September 1, 1985. Simmons's forte was finance, and to that end, he initiated periodical self-studies and strategic mission plans designed to define and realize objectives within a time span of five years. Under the Simmons administration, the university plunged into its most extensive building/rebuilding program since the 1960s.

RICHMOND POLICE ACADEMY. A 1992 agreement between VUU and the Richmond City Police Department resulted in the construction of the Richmond Police Academy on university property at Graham Road. This historic occasion marked the first time that a police academy was situated on the grounds of a university. (Courtesy of John McCorsley.)

DR. JULIE ANN MOLLOY (RIGHT) AND STUDENT DIAMOND ELAM. VUU's criminal justice department has held most of its classes at the police academy. The criminal justice major has become the university's largest major program under a series of capable chairs and faculty members, including William Gibson; James Johnson; Dr. Martin Greenberg; and Dr. Julie Ann Molloy, who has chaired the department since 2008. (Courtesy of Ayasha Sledge.)

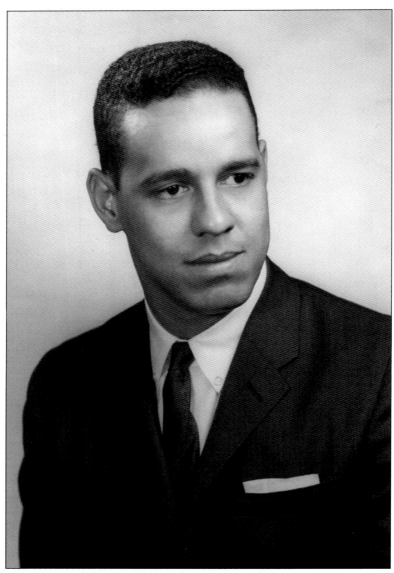

L. Douglas Wilder. Lawrence Douglas Wilder (pictured in 1964, when he was a young Richmond attorney) was born on January 17, 1931, and raised in the Church Hill neighborhood of Richmond. Wilder graduated from VUU in 1951 with a bachelor of science in chemistry. Shortly thereafter, he was conscripted into the US Army and went into combat during the Korean War. As a sergeant at the murderous Battle for Pork Chop Hill in 1953, Wilder distinguished himself for bravery under fire, capturing 19 prisoners and earning the Bronze Star. Wilder graduated from Howard Law School and, in 1969, successfully ran for the Virginia State Senate seat vacated by J. Sargent Reynolds, becoming the first African American Virginia state senator since Reconstruction. Wilder was subsequently elected Virginia's first African American lieutenant governor, serving from 1986 to 1990, then won election to become the first elected African American governor, a position he held from 1990 to 1994. Wilder ran for the Democratic Party presidential nomination in 1992 and was elected mayor of Richmond in 2004, serving until his retirement on January 1, 2009.

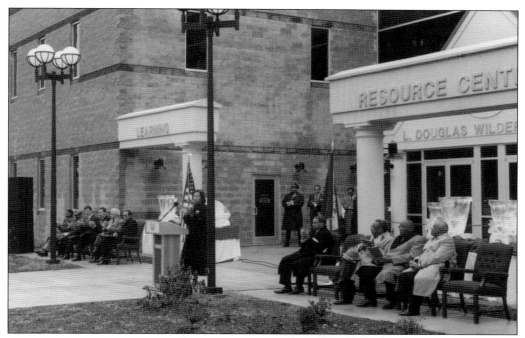

THE OPENING OF THE L. DOUGLAS WILDER LIBRARY AND LEARNING RESOURCE CENTER. The old William John Clark Library in the Belgian Building was inadequate for meeting the needs of the VUU community, and it was imperative that the library collections be housed in a more modern facility that could ease the transition from the card catalog system to a computerized one. On Founders' Day, February 14, 1997, the L. Douglas Wilder Library and Learning Resource Center was dedicated. On the extraordinary occasion, the speaker was former president Dr. Samuel Dewitt Proctor. After services, the crowd braved chilly weather to attend the dedication ceremony at the library's main entrance. (Both, courtesy of Doug Beurlein.)

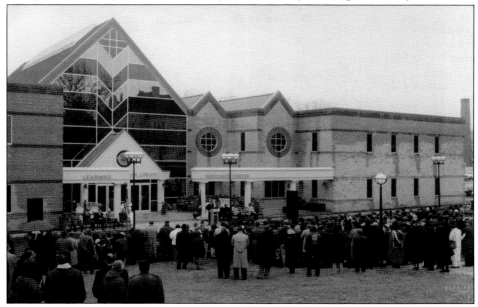

THE NEW LIBRARY. Since opening in 1997, the L. Douglas Wilder Library and Learning Resource Center has become a hub for research and scholarship and a repository for the university's historical documents under the oversight of successive directors Dr. Vonita Foster, Dr. Delores Pretlow, and Pamela Foreman. The Library Archives and Special Collections Department opened in 1997 and primarily focuses on Richmond's African American heritage. The library's special collections include the L. Douglas Wilder Collection, with documents and memorabilia from the former Virginia governor; the Dr. Jon Michael Spencer Collection of African American history and sacred music; and the Sampson-Watson Preaching Collection.

Dr. Frank S. Royal Sr. Dr. Royal graduated from VUU in 1961 and received his medical degree from Meharry University in 1968. In 1969, he established a still-prospering private family medical practice in Richmond. Dr. Royal was president of the National Medical Association from 1981 to 1983, chair of the board of trustees for Meharry as well as for Virginia Union from 1982 to 2011, and continues to serve as chairman emeritus.

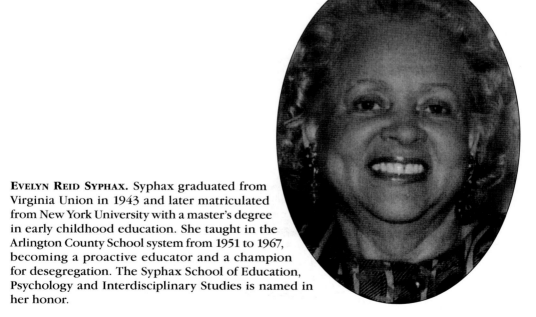

Evelyn Reid Syphax. Syphax graduated from Virginia Union in 1943 and later matriculated from New York University with a master's degree in early childhood education. She taught in the Arlington County School system from 1951 to 1967, becoming a proactive educator and a champion for desegregation. The Syphax School of Education, Psychology and Interdisciplinary Studies is named in her honor.

THE OLD CAMPUS BELL IN ITS NEW SETTING. The old campus bell is one of Virginia Union's enduring traditions. Used to designate the times of classes, it was strategically stationed just behind Pickford Hall, which, until 1966, was the main classroom building on campus. The honor of ringing the bell for classes was bestowed upon certain students. After Pickford was supplanted by the new Ellison Hall as the chief center for classes, the bell was moved to its current location between Ellison Hall and the Belgian Friendship Building. The habit of ringing the bell to signal class times went out of use, since many different buildings are used for classes, and the bell's peals could not possibly resonate loudly enough across campus. (Courtesy of Ayasha Sledge.)

RESTORATION CEREMONY AT KINGSLEY HALL. On February 13, 1998, after spending years in the C.D. King Building, the School of Theology was set to move into its new abode, the refurbished Kingsley Hall. Following the Founders' Day services, the building was specially consecrated to house the graduate school, which was then renamed the Samuel DeWitt Proctor School of Theology.

DR. JOHN KINNEY. The School of Theology was renamed in 1998 in honor of Samuel DeWitt Proctor, the man who had played a major role in VUU's growth and who had passed away the previous May. Since then, the school has prospered under its revered dean, Dr. Kinney. A graduate of the VUU School of Theology, Dr. Kinney received his doctorate from Columbia University/Union Theological Seminary in New York.

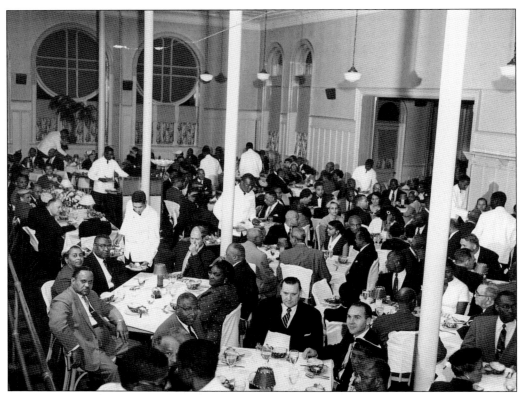

LOST VUU: MARTIN E. GRAY HALL (ABOVE) AND THE OLD COBURN CHAPEL STAGE (BELOW). While the devastating fires of 1970 and 1993 deeply saddened the Virginia Union family, they certainly did not detract from the mission or the ardor and enthusiasm of all who supported the school. Though much was irretrievably lost from a material point of view, the old Martin E. Gray and Coburn Halls remain etched in the memories of all who dined at Gray or attended services at Coburn. The Martin E. Gray dining hall hosted many convivial meetings and conversations, and the students assembled there in 1960 to launch the February sit-in. The Coburn Hall stage was the venue for significant campus events such as the "debate" between Booker T. Washington and W.E.B. Du Bois (who addressed the student body on separate occasions); Langston Hughes's recitation; and addresses by Martin Luther King Jr., Mary McLeod Bethune, Ralph Abernathy, William Howard Taft, and others.

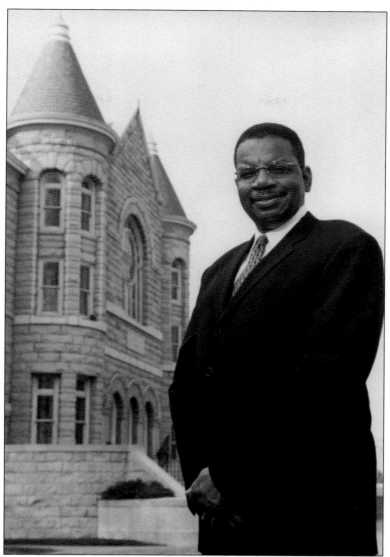

Dr. Bernard Wayne Franklin. Dr. Franklin was inaugurated as VUU's 10th president on September 22, 2000. He announced plans to bring the campus into the technological mainstream. This was accomplished in an amazingly brief time: on November 21, 2000, Virginia Union became the first institution of higher education in Virginia—and the first historically black college/university in the United States—to install a campus-wide wireless infrastructure (vuuNet). Dr. Franklin, born in Montclair, New Jersey, first attended Simpson College in Indianola, Iowa, receiving a bachelor's degree in religion. He earned a master's degree in education from Western Maryland College and a doctorate in education (higher education administration) from Teachers College at Columbia University. In 1988, Dr. Franklin came to Virginia Union as an ACE Fellow and then served as vice president for student affairs. He also worked at Johnson C. Smith College, where he was assistant vice president for student affairs; at Livingstone College and Hood Theological Seminary in Salisbury, North Carolina, as president (from 1989 to 1995); and at St. Augustine's College in Raleigh, North Carolina, as president (from 1995 to 1999).

Dr. Belinda Childress Anderson. Dr. Anderson was appointed president of VUU after Dr. Bernard Wayne Franklin assumed a position with the NCAA, and she served from 2003 to 2009. She was the first woman to hold the office. She earned her bachelor's and master's degrees in history at Radford University and her doctorate in education from Virginia Tech. She served as dean of the school of general and continuing education at Norfolk State University and with the State Council of Higher Education for Virginia before coming to VUU. Her administration moved the VUU art museum collection from White Hall to the Wilder Library, where it developed into an effective educational resource. The Center for Undergraduate Studies, designed to coordinate academic and student services and to facilitate freshman and sophomore advisement, was established on solid footing under its first dean/director, Dr. Weena I. Gaulin.

DR. CLAUDE GRANDFORD PERKINS. Dr. Perkins, who assumed the office of president on January 21, 2009, studied and received his doctorate in curriculum and supervision from Ohio University. In Richmond, Dr. Perkins was assistant superintendent for Richmond Public Schools. Subsequently, he was named superintendent of school in Kansas City, Missouri, and then Clark County, Nevada. In Las Vegas, Nevada, an elementary school built in 2007 was named Claude G. Perkins Elementary in his honor. At Albany State University, Dr. Perkins was associate vice president for academic affairs and dean of the graduate school. Under the keynote theme "The Promise of a Limitless Future," Dr. Perkins reinstated the VUU choir and band; established the fine arts program, a master of arts in curriculum and instruction, the Center for the Study of the Urban Child, the Center for International Studies, and the Center for Small Business Development. He made over $6 million in campus improvements, including the new Living and Learning Center which opened in Fall 2014.

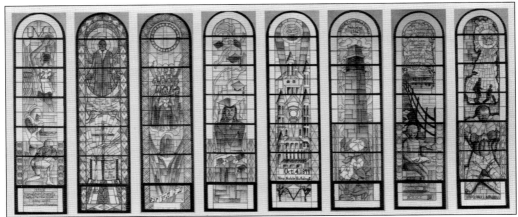

THE COBURN STAINED-GLASS WINDOWS. In 2010, the parishoners of Grace Baptist Church, located in Mount Vernon, New York, gifted VUU with eight stained-glass windows honoring their pastor of 35 years, Dr. W. Franklyn Richardson, and his wife, Inez Richardson, which were installed in Coburn Chapel. The windows cost $200,000 and depict slavery and the Underground Railroad, Lumpkin's Jail, the "Nine Noble Buildings," the Belgian Building, the School of Theology, the choir, academics, and athletics.

DR. W. FRANKLYN RICHARDSON. Dr. Richardson, a VUU alumnus, graduated in 1971 with a bachelor of arts degree, and earned a doctorate from United Theological Seminary in Dayton, Ohio, in 1975. He has pastored Grace Baptist Church in Mount Vernon, New York, since 1975. He is married to Inez Nunnally Richardson, a VUU alumna, and has chaired the university's board of trustees since 2011. In 2013, he was inducted into the National Black College Hall of Fame.

THE "VUU 34" MONUMENT STONE AT MARTIN E. GRAY HALL (ABOVE) AND MEMBERS OF THE VUU 34 IN 2010 (BELOW). February 2010 marked the 50th anniversary commemoration of the arrest of the "VUU 34." This seminal civil rights movement event had been sporadically remembered until, in 2004, Elizabeth Johnson Rice reenacted the 1960 march to the site of Thalhimers. Anniversary commemorations were held at Virginia Union, and in 2010, a major commemoration featured "34" members in attendance and being honored by seminars, films, dramatic productions, musical events, and the dedication of a monument in front of Martin E. Gray Hall. The monument was donated by the sculptor Tony Grappone through the efforts of VUU alumnus Larry Woodson. The top portion reads, in part: "In honor of the Virginia Union University students . . . who—dauntless and uncompromising in their quest for freedom—stood firm in the face of a racist, oppressive system."

FIRST LADY CHERYL PERKINS (RIGHT). The first lady of Virginia Union University is from Michigan, where she graduated from Cass Technical High School in Detroit. She holds three master's degrees and has served as an educator for nearly 30 years. Since coming to VUU, she has been active both on campus and in the community. She volunteers her time mentoring students and at the VUU art gallery, and she facilitates etiquette workshops on campus. Perkins is pictured here with VUU alumna Dr. Cora B. Marrett.

THE CHOIR. The fine arts fell on lean times during the 2000s, when arts programs were nearly eliminated at VUU. In 2011, the Claude G. Perkins administration reinstated the fine arts major and department. The choir—a tradition at VUU going back to the days of the Wayland Quartet of the 1870s—was revived under the capable directorship of Dr. Willis Barnett. A gifted composer, Dr. Barnett recently wrote *Emancipation Overture* to mark the sesquicentennial of the Emancipation Proclamation.

Seven

UNIVERSITY LIFE
THROUGHOUT THE YEARS

The effectiveness of an institution for higher education is most accurately measured by the regard in which it is held by its students and alumni and the impact that these alumni have had on the betterment of the world. Virginia Union University has had an impact far beyond its numbers and resources. It is all about the fundamentals, teacher to student. The school celebrates the strong and enduring tradition of the "Virginia Union Family," with manageable class sizes, a low student-faculty ratio, and a campus atmosphere in which multiple individuals collaborate to give students every opportunity to progress. Several truisms from the earliest days have not changed. One is the permanence Unionites feel toward their alma mater. Many faculty members have found that their duties of advising students have extended beyond graduation—and even past graduate school. Likewise, former students return to their old mentors for guidance and encouragement. As important as academics are in the VUU experience, it is also about athletics, student organizations, and the quality of life both on and off campus. In fact, Virginia Union's students and those who serve them have become like the Virginia granite walls of the original buildings; walls which, in the words of VUU's first president, Dr. Malcolm MacVicar, "will challenge and inspire every young man [or woman] who comes on this campus seeking an education."* (**Actual remarks altered to be more gender-inclusive.*)

YVONNE THOMPSON MADDOX. Yvonne Thompson was crowned Miss VUU in 1965, personifying the tradition of queen and "court" as university representatives. Like many Miss (and, since 2006, Mr.) VUU's, she has carried her VUU pride beyond graduation. As Dr. Yvonne Thompson Maddox, she became deputy director of the Eunice Kennedy Shriver National Institute of Child Health and Human Development.

ELIZABETH JOHNSON RICE. Rice, one of the VUU 34, became a founding member of the Student Nonviolent Coordinating Committee (SNCC). A longtime educator in Washington, DC, she is credited with reawakening interest in the 1960 Richmond sit-in. Pictured here are, from left to right, Ford Tucker Johnson Sr. (Elizabeth's father), Rev. Richard Rice (Elizabeth's husband), Elizabeth, and her sister Phyllis Johnson Richardson.

SIMEON BOOKER JR. Simeon Saunders Booker Jr. graduated from VUU in 1942, majoring in English. He subsequently joined the staff of the *Baltimore Afro-American*, then the *Cleveland Call & Post*, then the *Washington Post* (as its first African American reporter). Booker joined *Jet* magazine and became the premier African American reporter during the salient events of the civil rights movement—risking his life in many instances.

HARLOW FULLWOOD JR. (1941–2007). Fullwood (right), pictured here with Dr. David Shannon, gained football All-America honors at VUU. He served for 23 years as an officer in the Baltimore Police Department, later gaining success as an entrepreneur, founding Fullwood Foods, Inc., and running two of Kentucky Fried Chicken's most successful franchises. In 1984, he founded the Fullwood Foundation to raise funds for educational scholarships and special grants to human services organizations.

MAX ROBINSON. Max Cleveland Robinson Jr. and his equally famed brother, Randall, grew up in Richmond's Jackson Ward. Max attended VUU, then transferred to Oberlin. After entering broadcast journalism at the ground level, he attracted notice because of his eloquence and screen presence. In 1978, Robinson became the first African American news anchor for a major network station on the ABC program *World News Tonight*.

RANDALL ROBINSON. Randall Robinson became an internationally celebrated social activist, author, and historian. He graduated from VUU with a bachelor's degree in sociology and received a Juris Doctor from Harvard Law School in 1970. He founded the TransAfrica Forum, picketing the South African embassy in protest against apartheid, and prodded the Clinton administration into intervening against Haiti's military junta. A resolute proponent of reparations to the African American community in compensation for slavery and Jim Crow, Randall became a prolific best-selling author.

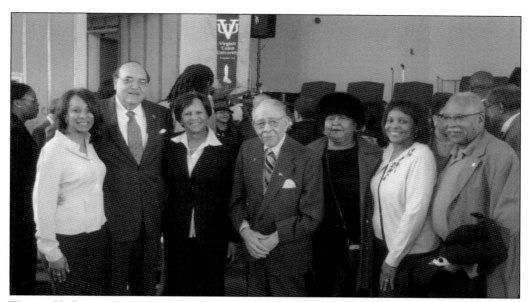

WESLEY T. CARTER SR. (1907–2012). Pictured here at age 102, Dr. Carter (center) strikes a pose with VUU president Claude G. Perkins (second from left), "VUU 34" member Barbara Thornton Nero (third from left), her family, and former classmate Frances Barcroft Dalton (third from right). Carter graduated from VUU in 1929, enjoyed a long career as an educator, and was instrumental in planning the Bill "Bojangles" Robinson statue in Richmond's Jackson Ward. He attended nearly every VUU event until shortly before his passing.

ROSLYN MACALLISTER BROCK. Roslyn McAllister Brock became active in the NAACP from the moment she joined the VUU chapter in 1984 as a freshman. She graduated from VUU in 1988 and has worked in the health care industry for W.K. Kellogg Foundation and Bon Secours Hospitals. A vibrant and engaging speaker, Brock rose within the NAACP ranks to become, in 2010, the youngest chair of the NAACP's board of trustees.

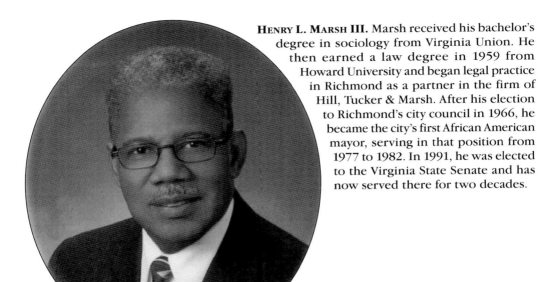

HENRY L. MARSH III. Marsh received his bachelor's degree in sociology from Virginia Union. He then earned a law degree in 1959 from Howard University and began legal practice in Richmond as a partner in the firm of Hill, Tucker & Marsh. After his election to Richmond's city council in 1966, he became the city's first African American mayor, serving in that position from 1977 to 1982. In 1991, he was elected to the Virginia State Senate and has now served there for two decades.

DR. Dwight C. **JONES.** Dr. Jones earned a bachelor's of sociology (in 1970) and a master's of divinity (in 1973) from VUU before earning his doctorate in the ministry at Union Theological Seminary in Dayton, Ohio. Jones chaired the Richmond City School Board from 1982 to 1985 and was elected to the Virginia House of Delegates, where he held a seat for 14 years before becoming the second popularly elected African American mayor of Richmond, in 2008.

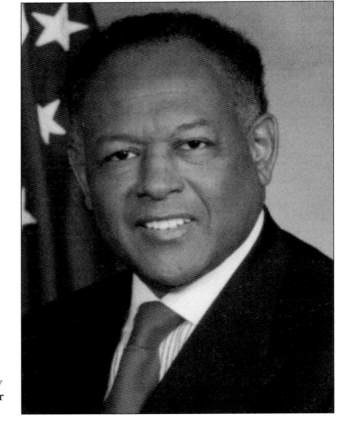

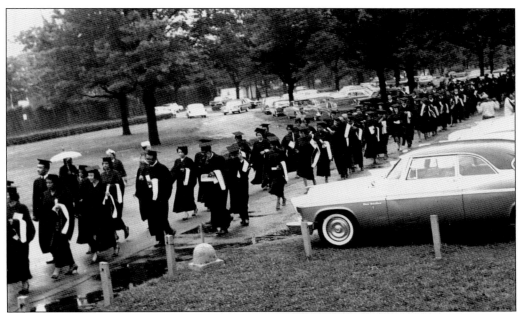

GRADUATION PROCESSIONS, 1963 (ABOVE) AND 1964 (BELOW). Commencement—the intoxicating dream of every student struggling through four (or more) years of study—culminates in excitement, pageantry, parental pride, and celebration. Virginia Union's commencements have been held at varying venues depending on weather and building availability. The favored on-campus locations include Coburn Hall, Barco-Stevens Hall, and Hovey Field. Dr. John Watson was university marshal for so many years that it was customary to see his imposing frame leading the students through heat and rain. Dr. Franklin Johnson Gayles Jr., walking behind Dr. Watson in the 1964 photograph (first and second from left), was the Gordon Hancock Professor of Political Science, department chair, dean, and a civil rights trailblazer who, in 1977, won election as the first African American Richmond city treasurer since Reconstruction.

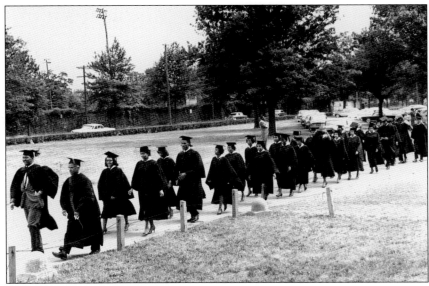

CAFETERIA LIFE. What would college life be without a place, be it ever so humble, to eat and hang out with friends? The first student hangout on campus was the Old Pie Shop, which was managed and operated in the Pickford Hall basement by coach Henry Hucles and his wife. Students from the 1930s recall the huge, thick pieces of pie, which were cut into quarter-servings and cost 5¢ apiece. A serving of pie and a drink could usually tide one over for quite a while. The shop encompassed a small area, and space was at a premium. There was only room for a counter and five tables, and students were allowed just 15 minutes to sit and finish a snack. Each year, a student was voted the "Pie Shop Pest." The Old Pie Shop (not pictured) was closed by the 1950s.

GREEK LIFE. Greek letter organizations have been a part of VUU ever since Eugene Kinckle Jones, one of the founding "jewels" of the Alpha Phi Alpha fraternity, founded the Gamma Chapter in 1907 while visiting his parents on campus; these organizations continue to have a tremendous impact. On October 28, 1919, the Zeta Chapter of Omega Psi Phi fraternity was established at Virginia Union; on May 9, 1921, Phi Beta Sigma fraternity founded its Lambda Chapter. The first sorority on campus was the Nu Chapter of Zeta Phi Beta (May 1, 1926), then the Alpha Eta Chapter of Alpha Kappa Alpha (April 7, 1928), Tau Chapter of Sigma Gamma Rho (January 30, 1930), Beta Epsilon Chapter of Delta Sigma Theta (December 4, 1937), and Alpha Gamma Chapter of Kappa Alpha Psi. In January 2009, Iota Phi Theta was established on campus.

THE VUU MUSEUM GALLERIES AND HISTORY PANELS. It is important for students to have access to tools for learning outside the classroom, and within the walls of the L. Douglas Wilder Library, two such tools are readily available. The VUU Museum Galleries, which moved from White Hall to the library in 2004, has an outstanding collection of Western and Central African art (donated by Dr. James Sellman and his wife); Oceanic art (donated by Drs. George and Lois Kriegman); and an extensive African American folk art collection, including the second-largest collection of the works of Thornton Dial. In the fall of 2008, work was completed on the installment of the VUU history panels. The panels, which adorn the walls of the library reference room, relate and illustrate the history of VUU. The panels are modelled on those at the University of Arkansas at Pine Bluff.

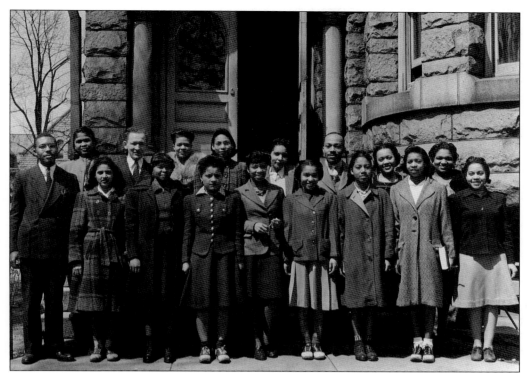

STUDENT ORGANIZATIONS: LIBRARY CLUB (ABOVE), 1930S; J.E. JONES LYCEUM (BELOW), 1970S. Two literary societies were organized quite early at Wayland Seminary: the Wayland Lyceum for men and the Elizabeth W. Wayland League for ladies. After 1899 and the forging of the "union" of institutions, extracurricular organizations flourished at VUU. During the 20th century, VUU has hosted student clubs such as the Kappa Gamma Chi Literary and Debating Society, Joseph Endom Jones Oratorical Club, Philharmonic Society, Union Savings Bank, Musical Club (incorporating the Glee Club and the Mandolin Club), Club for the Study of Socialism, Wakefield Chemical Society, Dramatics Club, Art Club, Alpha Kappa Mu Honor Society, Foreign Students' Association, Veterans' Club, Future Teachers of America (FTA), Lope de Vega Club, Karate Club, Joy Christian Fellowship, and the WIZ Group.

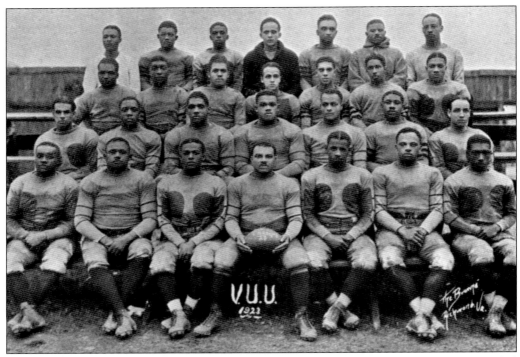

VUU FOOTBALL (ABOVE) AND BASEBALL (BELOW) TEAMS, 1922. Although VUU has always prided itself on its academic side, athletics have long been a mainstay of student life on Lombardy Street. In 1923, VUU's football team won the first of six national sports championships achieved by the Panther athletic program. The team, coached by Harold Douglas Martin, went undefeated, with a 6-0 record, en route to the CIAA Championship as well as the national title. It was not until 1948 that the football squad again captured national honors, compiling a 6-5 record under coach Sam Taylor. Coach Martin left VUU in 1924, became CIAA commissioner, and joined the Air Force during World War II, serving as a ground instructor to the Tuskegee Airmen. Martin died in a plane crash on March 23, 1944.

COACH HENRY HUCLES AND ASSISTANTS. One of the most colorful athletes at VUU, Henry B. Hucles (1897–1979) played sports at VUU, then became head football, basketball, and baseball coach from 1919 to 1920, winning the CIAA baseball championship. After a stint as head coach at Prairie View A&M, Hucles returned to VUU as a coach and athletic director; he held the latter position until 1950. For many years thereafter, he was a health and physical education instructor. Coach Hucles was noted for his unpredictability and penchant for doing everything necessary to win. From 1942 to 1943, future Major League Baseball Hall of Famer Larry Doby played on the VUU basketball squad under Hucles's tutelage.

SAMUEL B. JENKINS
HENRY B. HUCLES, III
BERNARD SCOTT SMITH

1940 BASKETBALL "DREAM TEAM" (ABOVE) AND COACH DAVE ROBBINS AND 1980 CIAA CHAMPIONS (BELOW, COACH ROBBINS AT FAR RIGHT). VUU's storied sports heritage includes the men's basketball 1939–1941 "Dream Team," which, in 1939, defeated Long Island State, which was officially—in the days of segregation—the number one team in the nation. When athletic director Thomas Harris brought in Robbins to direct the basketball program in 1978, it caused a stir since he was the first (and only) white head coach at a historically black institution. This subsided when Robbins amassed an amazing record that included national championships in 1980, 1992, and 2005. When Robbins retired in 2008, his record stood at 713 wins against 194 losses, and athletes he coached included NBA stars Charles Oakley, Ben Wallace, Terry Davis, and A.J. English.

FRED "CANNONBALL" COOPER (ABOVE, NO. 22) AND 1940S VUU "PIGSKIN" ACTION VS. ST PAUL'S (BELOW). Larry Doby aside, Cooper was the most famous VUU athlete of the 1930s and 1940s. Cooper went to VUU from 1938 to 1943 and dominated the CIAA as one of the most punishing fullbacks that the league has ever seen. In fact, he was dubbed "Cannonball" because of his unerring ability to knock down defenders. He left VUU before graduating to join the Army but returned in 1946 to complete his degree. Cooper broke segregation boundaries in the South in 1949 as the first African American to play for the Richmond Rebels professional football team. Cooper coached the Maggie Walker Green Dragon football team, amassing a 91-18-1 record.

COACH THOMAS "TRICKY TOM" HARRIS (TALLER MAN AT LEFT) AND 1960S BASKETBALL ACTION. Succeeding Henry Hucles was equally flamboyant and legendary coach Harris, whose name became a byword for audacity and innovation. At first, Harris served as VUU athletic director (from 1950 to 1982). In 1978, he enabled the hiring of men's basketball coach Dave Robbins. Harris was active to the end, inspiring the women's basketball team to within one victory of the 1982 CIAA women's basketball championship in its game against Norfolk State. During the course of the game, with VUU leading by one point, Harris was suddenly felled by a heart attack that would prove fatal. The women had the choice of continuing to play or splitting the championship with their opponents.

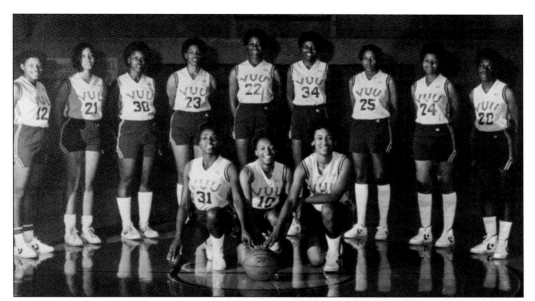

THE "WOMEN'S DREAM TEAM" (ABOVE) AND COACH LOUIS HEARN. With their revered coach Tom Harris stricken by a heart attack during the 1982 championship game, the VUU women's basketball squad decided to complete the game. Directed by assistant coach Louis Hearn, they defeated Norfolk State that day, won the CIAA crown and, as the "Women's Dream Team," earned legendary status. In the 1983 season, they ran rampant over the competition, posted a 27-2 record, and won the NCAA Women's Division II Basketball National Championship. Hearn went on to serve VUU for many years as one of the founders of the Honda Campus All-Stars Team and director of the Upward Bound Program. One of the stars on the "Women's Dream Team," Barvenia Wooten-Cherry, returned to VUU in 2009 as the head coach of women's basketball.

STUDENTS PERFORM *THE MARRIAGE OF FIGARO* AT LA CAVE THEATRE (ABOVE) AND *LUMPKIN'S JAIL* AT BELGIAN THEATRE (BELOW). Theater and drama have long been part of VUU's presence in Richmond, where the productions of the VUU Players have entertained members of the VUU family and people in the Richmond community. The offerings have ranged from Shakespeare to Lorraine Hansberry. The venues have also been diverse, from the improvised La Cave Theatre in the basement of the Martin E. Gray Hall to the more elaborate Belgian Theatre. One of the more unusual recent productions was staged in February 2010 in honor of the 50th anniversary of the "VUU 34" arrests; *Lumpkin's Jail* was based on the circumstances relating to the founding of Virginia Union and written by VUU alumnus Gregory Thornewell. It depicted historic events, with actors playing Mary Lumpkin, Dr. Nathaniel Colver, and Dr. Charles Corey.

FACULTY LEGEND CAROLYN WOODS DAUGHTRY. Daughtry graduated from Virginia Union in 1943 and studied for her master's degree at the State University of New York at Buffalo. In 1979, she was appointed dean of students at VUU. Her tenure as dean of students was one of the most successful in the university's history; she was immensely popular with the students. Dr. David Thomas Shannon named her provost in 1984, and she became the second female chief executive at VUU, serving from June to September 1985. Although her tenure in office was brief, Daughtry accomplished two major initiatives on behalf of her alma mater: the establishment of a presidential scholarships program and the office of enrollment management. She retired at the end of the 1986 spring semester. The yearbook staff probably best expressed the student body's sentiment on the occasion of her retirement in one of the most touching tributes ever tendered to an administrative officer: "To you our beloved Mrs. Carolyn Woods Daughtry, we the students of VUU dedicate the 1985–1986 edition of *The Panther*. You will always be in our hearts."

FACULTY LEGENDS RONALD SHELTON (ABOVE) AND DR. DELORES PRETLOW (LEFT). Virginia Union is blessed with caring and conscientious faculty members who, following the earliest traditions of the school, focus on the needs of individual students and quietly and unobtrusively work to facilitate their passage into the post-graduation world. Two such dedicated people carried this tradition at the L. Douglas Wilder Library. Dr. Pretlow (1946–2012), earned a master's degree in library science at Drexel University in 1969 and a doctorate in educational administration at George Washington University in 1983. Before coming to VUU, where she was Wilder Library director from 2003 to 2012, she was in charge of the Richmond Public Schools libraries. Shelton (1953–2014) graduated from VUU in 1985 and worked for many years at Wilder Library as a theological librarian and interlibrary loans specialist. Both Shelton and Pretlow were pillars of strength devoted to the welfare of students.

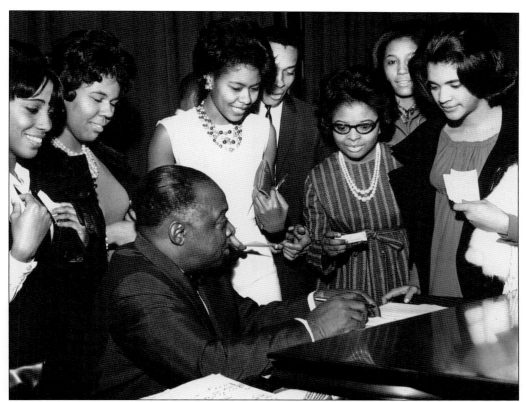

STUDENTS GATHERING AROUND COUNT BASIE (ABOVE) AND LOUNGING IN THE GRASS NEAR THE DUCK POND (BELOW). What is any university without its lifeblood—the students, who are the very reason for its existence? There is an eternal rhythm and resonance to student life that is constant regardless of the place, time, or institution. At VUU, the collegiate experience has ranged from mingling with successful role models like Count Basie to relaxing as one wishes—together with friends, alone in thought, at the old duck pond in front of Baptist Memorial, on the Hovey Field bleachers, or in one's dorm room. As VUU prepares to celebrate its 150th anniversary, it can reflect on a solid record of fulfilled hopes and achievements.

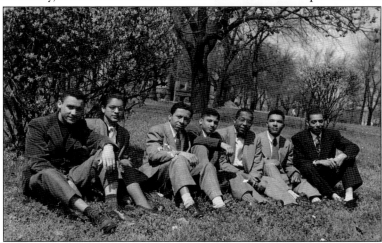

Discover Thousands of Local History Books Featuring Millions of Vintage Images

Arcadia Publishing, the leading local history publisher in the United States, is committed to making history accessible and meaningful through publishing books that celebrate and preserve the heritage of America's people and places.

Find more books like this at
www.arcadiapublishing.com

Search for your hometown history, your old stomping grounds, and even your favorite sports team.

Consistent with our mission to preserve history on a local level, this book was printed in South Carolina on American-made paper and manufactured entirely in the United States. Products carrying the accredited Forest Stewardship Council (FSC) label are printed on 100 percent FSC-certified paper.